How to Draw Comics the Marvel Way

by
Stan Lee
and
John Buscema

A FIRESIDE BOOK
Published by Simon & Schuster, Inc.
NEW YORK

Copyright © 1978 by Stan Lee and John Buscema
All rights reserved
including the right of reproduction
in whole or in part in any form
First Fireside Edition, 1984
Published by Simon & Schuster, Inc.
Simon & Schuster Building
Rockefeller Center
1230 Avenue of the Americas
New York, New York 10020

FIRESIDE and colophon are registered trademarks of Simon & Schuster, Inc.

Designed by Dorothy L. Gordineer

Manufactured in the United States of America

19 18 17 16 15 14 13 12
10 9 8 7 Pbk.

Library of Congress Cataloging in Publication Data

Lee, Stan.
 How to draw comics the marvel way.
 1. Comic books, strips, etc.—illustrations.
2. Drawing—Techniques. I. Buscema, John. II. Title.
NC1764.L4 741.5 77-20226.

ISBN 0-671-22548-0
ISBN 0-671-53077-1 Pbk.

Dedicated to John Buscema, the Michelangelo of the comics.

Stan Lee

Dedicated to Stan Lee, who knows talent when he sees it.

John Buscema

Oh well, you win some, you lose some!

Stan

But seriously, folks —

Dedicated to every wide-eyed guy or gal who has ever held a pencil, pen, or crayon and dreamed of telling fantastic stories through pictures; to everyone who's ever thrilled to the sight of a dazzling drawing and longed to be able to copy it, or better still, to create an original!

In short, to everyone and anyone who's ever wanted to be—a comic-book artist! You're our kind of people. We know just how you feel. You see, we've been there ourselves!

Stan & John

CONTENTS

PREFACE

I've been planning to write this book for years, but it took Big John Buscema to light the fire and get the whole thing started. Here's how it happened.

You know how it is. You intend to paint the barn, or mow the lawn, tidy up your room, or write a book—but you keep putting it off because there are a zillion other things you'd rather do. Well, that's the way it was with me. I've spent so many years as editor, art director and writer of so many superhero yarns that I just couldn't bring myself to write the one book that I knew would have to be written sooner or later—the one book that Marvel fans everywhere always ask for whenever I deliver one of my lilting little lectures on some campus or other. Namely, the book you're now so gratefully grasping in your pencil-smudged little paws.

Why has it been so eagerly requested? Simple. You see, while there's a veritable plethora of "How to Draw" manuals gallantly glorifying any bookseller's shelves, up to now there's been no book available to tell a budding young Buscema, or Kirby, Colan or Kane how to draw *comicbook superheroes,* and—most importantly —how to do it in the mildly magnificent Marvel style. Yep, I knew I'd have to write it someday, and it all came together when Big John organized his comicbook workshop.

Early in '75 Johnny told me he was going to teach a course in drawing for the comics. My curiosity aroused, I visited one of his classes and was absolutely amazed at the quality and depth of his instruction. You know how rare it is to find the foremost person in some field who can actually teach as well as perform. Well, take it from me, I had certainly found him that day—and I was doubly fortunate in that he was a longtime friend as well as a co-worker at Marvel Comics.

After viewing the success of his popular art course, I finally told Johnny that I felt it was a shame only a comparative handful of students could learn what he had to teach about comicbook artwork—a shame that so few were able to sit at the feet

of the master. Then I planted the seed. If he were to illustrate a book on the subject, he could reach thousands of aspiring artists all at the same time. Obviously, no one book can substitute for an entire art course, but at least we'd be able to present a broad overview, illustrating the most important elements of style, drama, and design that go into the making of a Marvel superhero feature.

Without looking up from his drawing board, he mumbled his usual monosyllabic grunt, which long years of friendship had taught me to interpret as a note of assent. Spurred on by his display of unbridled enthusiasm, I knew the project could be delayed no longer. John Buscema would organize, prepare, and illustrate our book—based on the highly successful course he teaches in his own workshop—and I would do the writing and sneakily steal a disproportionate share of the credit, as is my wont. So, here we are!

Okay, I won't keep you from the good stuff any longer. Just remember one thing. The pages that follow were created to give you an informed insight into the way the most popular comicbook superhero strips are designed and illustrated. They'll bring you as many artistic tips, tricks, secrets, and suggestions as possible. They'll show you what we strive for in doing our drawings, and how we go about achieving our unique objectives in art and design. We've tried to condense our own long years of training, toil, and experience into this one valiant little volume. And, in return, all we ask of you is—

Don't tell our competition what you've learned!

Excelsior!

Stan Lee
New York 1977

THE TOOLS–
AND THE TALK– OF THE TRADE!

Since very few of us draw with just our fingernails, let's start
off with what you'll need. Then we've got to make sure we're
all speaking the same language. This part's the easiest.

Here we go! On these two pages you'll find just about everything you'll need to get you started. One of the nice things about being a comicbook artist is the fact that your equipment is no big deal. Let's just give the various items a fast once-over . . .

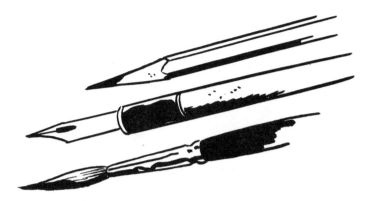

Pencil. Some artists prefer a soft lead, some like the finer hard lead. It's up to you.

Pen. A simple drawing pen with a thin point, for inking and bordering.

Brush. Also for inking. A sable hair #3 is your best bet.

India ink. Any good brand of black india ink is okay.

White opaquing paint. Invaluable for covering errors in inking.

Erasers. One art gum and one smooth kneaded eraser —which is cleaner to use.

A glass jar. This holds the water for cleaning your brushes.

Pushpins. Handy for keeping your illustration paper from slipping off the drawing board.

Triangle. A must for drawing right angles and working in perspective.

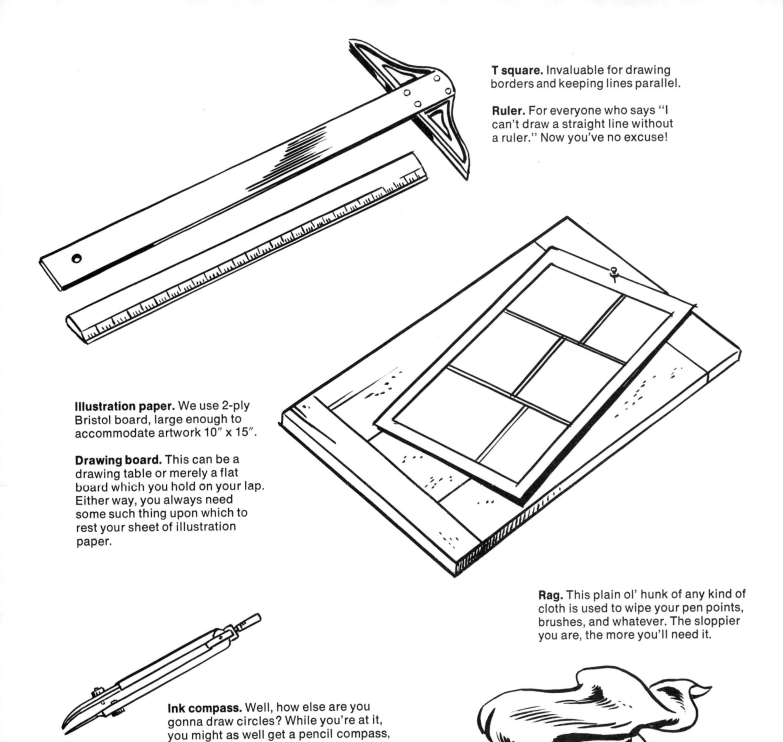

T square. Invaluable for drawing borders and keeping lines parallel.

Ruler. For everyone who says "I can't draw a straight line without a ruler." Now you've no excuse!

Illustration paper. We use 2-ply Bristol board, large enough to accommodate artwork 10″ x 15″.

Drawing board. This can be a drawing table or merely a flat board which you hold on your lap. Either way, you always need some such thing upon which to rest your sheet of illustration paper.

Rag. This plain ol' hunk of any kind of cloth is used to wipe your pen points, brushes, and whatever. The sloppier you are, the more you'll need it.

Ink compass. Well, how else are you gonna draw circles? While you're at it, you might as well get a pencil compass, too—even though Johnny forgot to draw one for you.

Of course, there are some things we omitted, like a chair to sit on and a light so that you can see what you're doing in case you work in the dark. Also, it's a good idea to have a room to work in— otherwise your pages can get all messy in the rain. But we figured you'd know all this.

And now, onward!

Just to make sure we all use the same language and there's no misunderstanding when we refer to things, let's review the various names for many of the elements that make up a typical comicbook page.

A: The first page of a story, with a large introductory illustration, is called the **splash page.**

B: Letters drawn in outline, with space for color to be added, are called **open letters.**

C: Copy which relates to a title is called a **blurb.**

D: The name of the story is, of course, the **title.**

E: An outline around lettering done in this jagged shape is called a **splash balloon.**

F: A single illustration on a page is called a **panel.**

G: The space between panels is called the **gutter.**

H: You won't be surprised to know that this "ZAT" is a **sound effect.**

I: Copy which represents what a character is thinking is a **thought balloon.**

J: The little connecting circles on thought balloons are called **bubbles.** (We'd feel silly calling them "squares"!)

K: The regular speech indicators are called **dialogue balloons.**

L: The connecting "arrows" on dialogue balloons, showing who is speaking, are called **pointers.**

M: The words in balloons which are lettered heavier than the other words are referred to as **bold words,** or **bold lettering.**

N: This is my favorite part—where the names are. We call it the **credits,** just like in the movies.

O: All this little technical stuff, showing who publishes the mag and when and where, usually found on the bottom of the first page, is the **indicia** (pronounced *in-deé-shah).*

P: Copy in which someone is talking to the reader, but which is not within dialogue balloons, is called a **caption.**

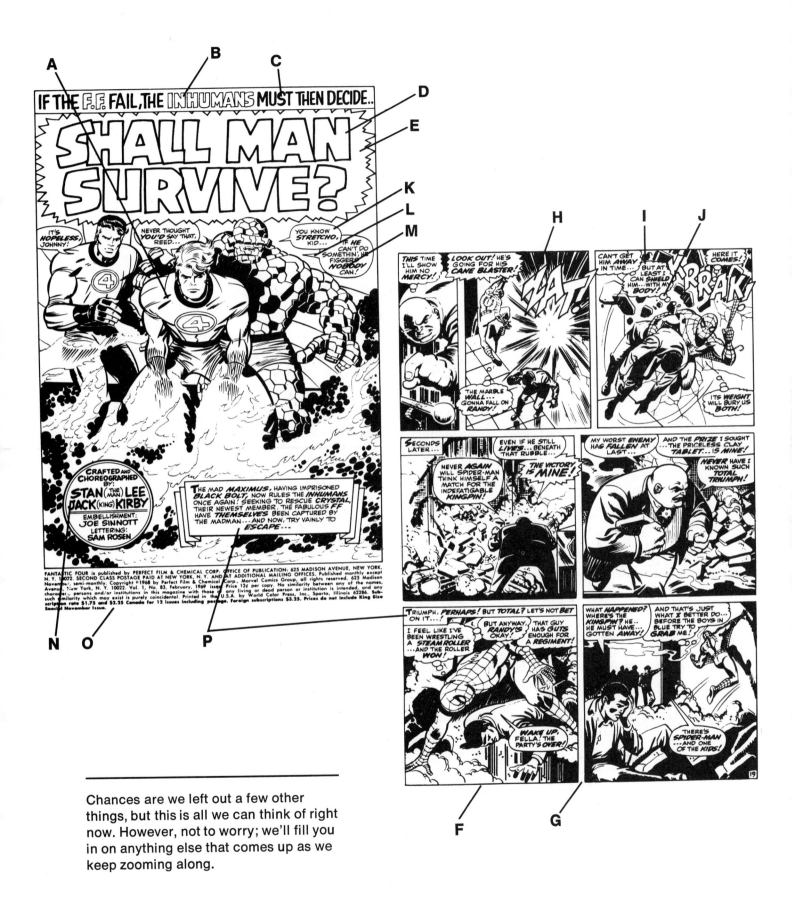

Chances are we left out a few other things, but this is all we can think of right now. However, not to worry; we'll fill you in on anything else that comes up as we keep zooming along.

Movin' right along, we now introduce you to one of Marvel's many widely heralded **close-ups,** so called because the "camera" (meaning the reader's eye) has moved in about as close as possible.

This type of panel, in which the reader's view of the scene is from farther away, enabling him to see the figures from head to toe, is called a **medium shot.**

And here we have a **long shot.** In fact, since it shows such an extreme wide-angle scene, you might even call it a **panoramic long shot** without anyone getting angry at you.

When you're up above the scene, looking down at it, as in this panel, what else could you possibly call it but a **bird's-eye view?**

On the other hand, when you're below the scene of action, as in this panel, where your eye-level is somewhere near Spidey's heel, we're inclined to refer to it as a **worm's-eye view.**

A drawing in which the details are obscured by solid black (or any other single tone or color) is called a **silhouette.** And now that we agree upon the language, let's get back to drawing the pictures . . .

THE SECRETS OF- FORM!
MAKING AN OBJECT LOOK REAL.

Anyone, even you or I, can draw some sort of circle or square. But how do we make it look like the real thing? How do we make a reader feel as if he can just reach out and touch it? How do we stop it from just lying there, flat and one-dimensional, on the page? How do we give it *length* (pretty easy), *width* (not hard), and *depth* (this is the tough one)? In short, how do we give it the proper **form?**

Now that we've bothered to ask, let's see how Big John can help us find the answers . . .

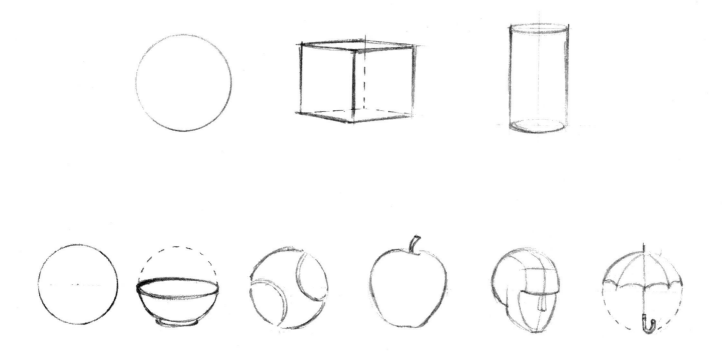

One of the main things that can ruin a drawing is the appearance of FLATNESS. Too many beginning artists, and even some old-timers, tend to concentrate on *height* and *width,* while neglecting the vitally important dimension of *depth*—which is just another name for *thickness.*

To say it another way, whatever you draw should seem to have *thickness.* It should have bulk, body, weight. It should seem solid. If it just looks flat, it won't make it.

You've got to train yourself to *think* of everything you draw as being solid—as having bulk. John calls this "thinking through the object." Think all around it—think of its sides as well as its top and bottom.

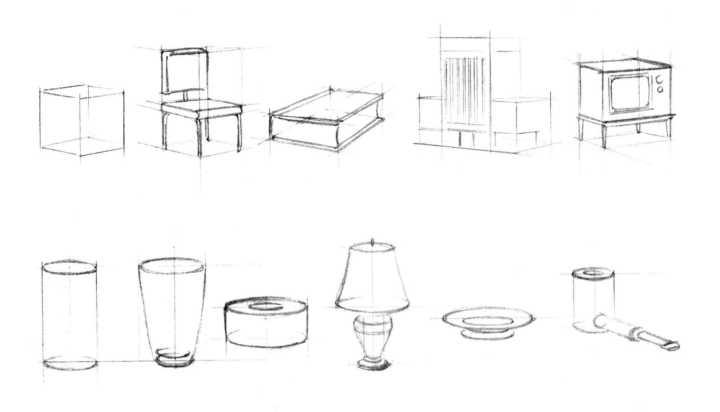

Incidentally, don't get impatient with this elementary stuff. We know you're anxious to start drawing Captain America battling Dr. Doom, but even Buscema had to have all this preliminary jazz down pat first—honest. Stay with it for the next few pages and we promise you'll find it much easier to do the difficult drawings when you come to them. End of commercial!

See the sketches on the opposite page? They serve to illustrate that most objects can be reduced to three simple geometric shapes—A) the SPHERE (or ball), B) the CUBE (or box), C) the CYLINDER (or pipe). As we move along, you'll see that most every drawing is based on one or more of these three key shapes.

Here we see a simple handgun, without which there could hardly be any comicbooks, or TV action shows, or movies. And, if you ever want to draw a Western strip, you'd better take particular note of the fact that the barrel is really a simple *cylinder,* the bullet chamber is a *cylinder* encased in a *cube,* and the butt is based upon the basic shape of a *cube*. Obviously, the outer shape is modified and altered to suit the desire of the artist and the purpose of the drawing, but the thing to remember is the actual sphere-cube-cylinder construction beneath a drawing.

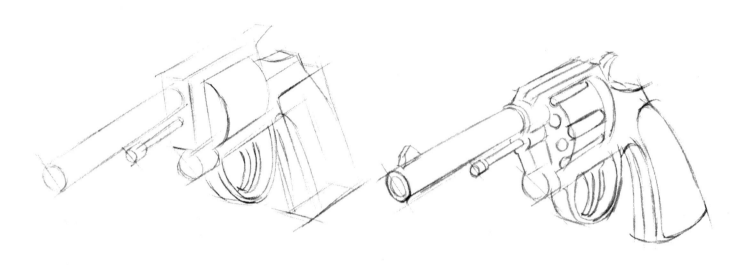

Now let's consider the automobile. Notice how there's a large *cube* representing the shape of the body, with a smaller *cube* denoting the window and roof area. As for the wheels—*cylinders,* of course.

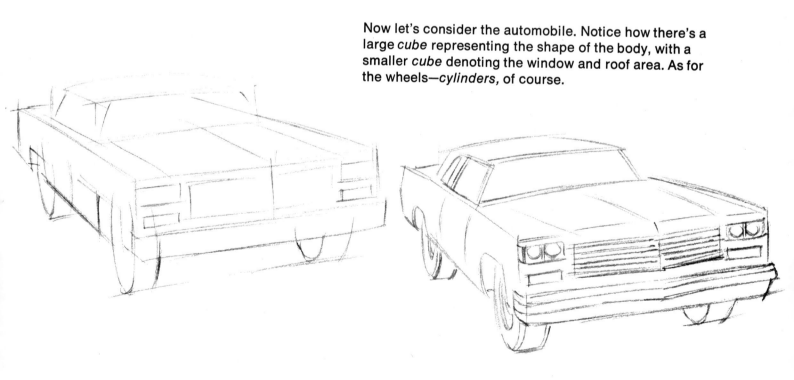

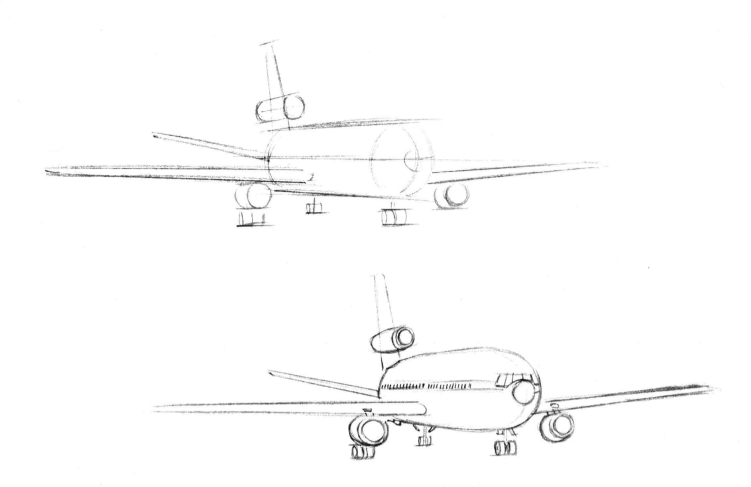

The plane is equally easy. As you can
see, it's composed of a number of simple
cylinders.

The purpose of this little exercise is to train you to "think through" the
objects you see, the objects you want to draw. Don't just see them as they
are, but rather see them as made up of any combination of our three basic
shapes. "Sphere, cube, and cylinder" may be the most important words we
can teach you—next to Make Mine Marvel, of course!

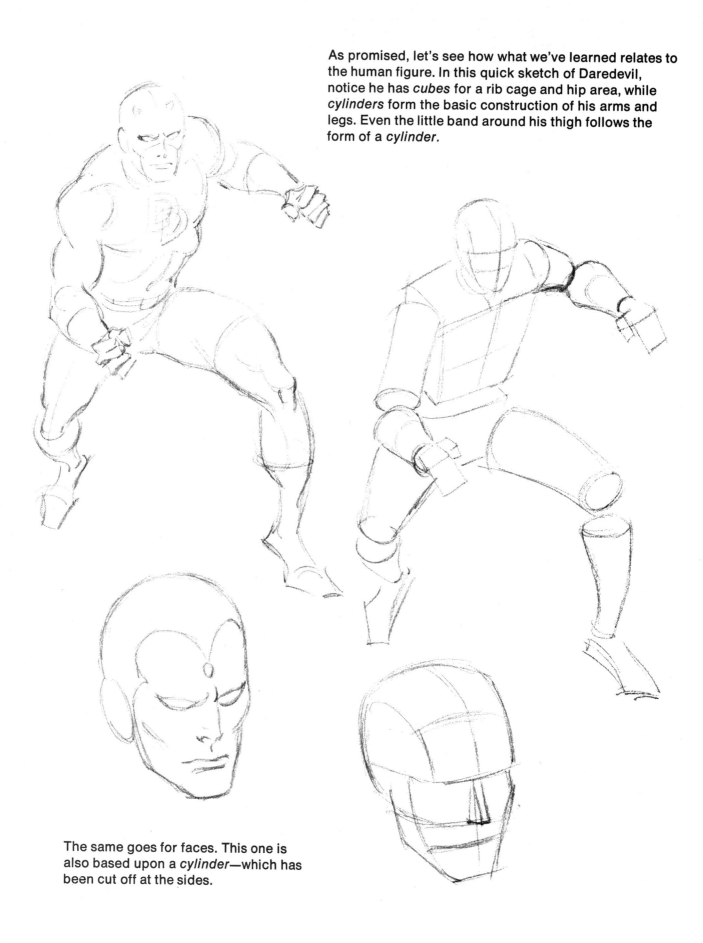

As promised, let's see how what we've learned relates to the human figure. In this quick sketch of Daredevil, notice he has *cubes* for a rib cage and hip area, while *cylinders* form the basic construction of his arms and legs. Even the little band around his thigh follows the form of a *cylinder.*

The same goes for faces. This one is also based upon a *cylinder*—which has been cut off at the sides.

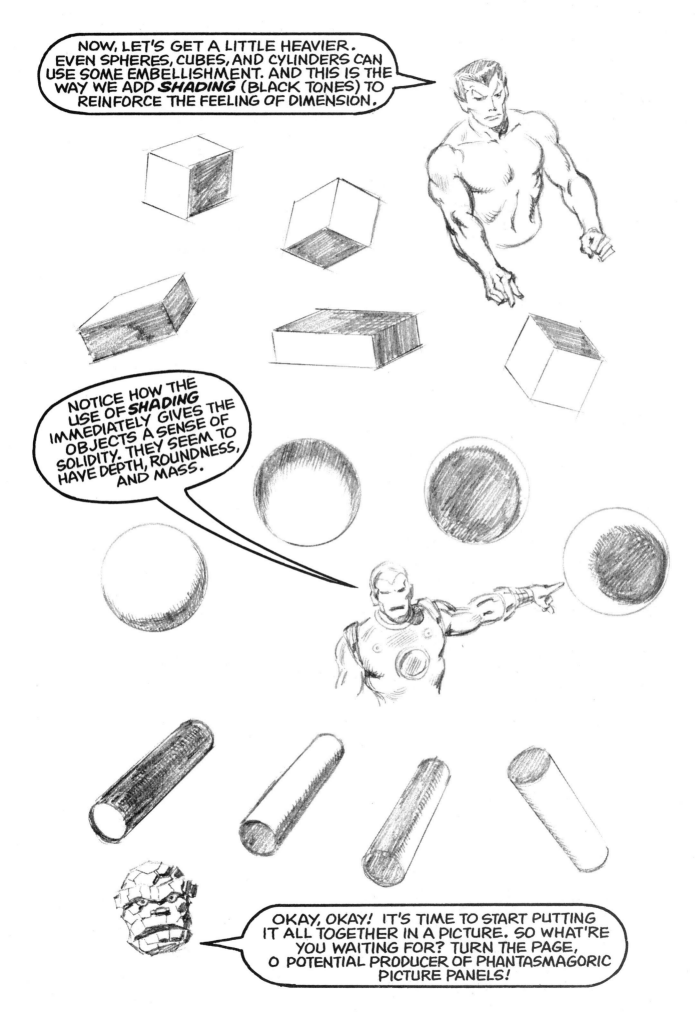

Below, on the left side of the page, you'll see two typical panels done in the Marvel style. Next to them, on the right, we've attempted to demonstrate what we've been saying for the past few pages. The top drawing is obviously composed of a *sphere,* plus a number of *cylinders,* with a *cube* on the bottom. The other panel depicts a flying car which, despite its unique and oddball shape, is nevertheless still based on our good ol' *cube,* somewhat modified to be sure.

The important thing about all this is to train you to think in terms of spheres, cubes, and cylinders whenever you see or draw any object. Once it becomes a habit with you, you'll find your drawings will begin to assume the proper form which seems to make them come alive.

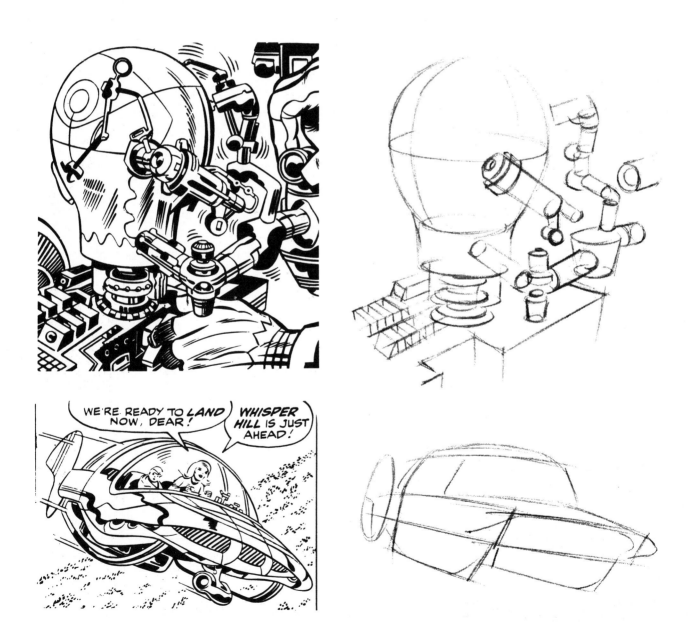

Here's more of the same, just to make sure we've left nothing out.

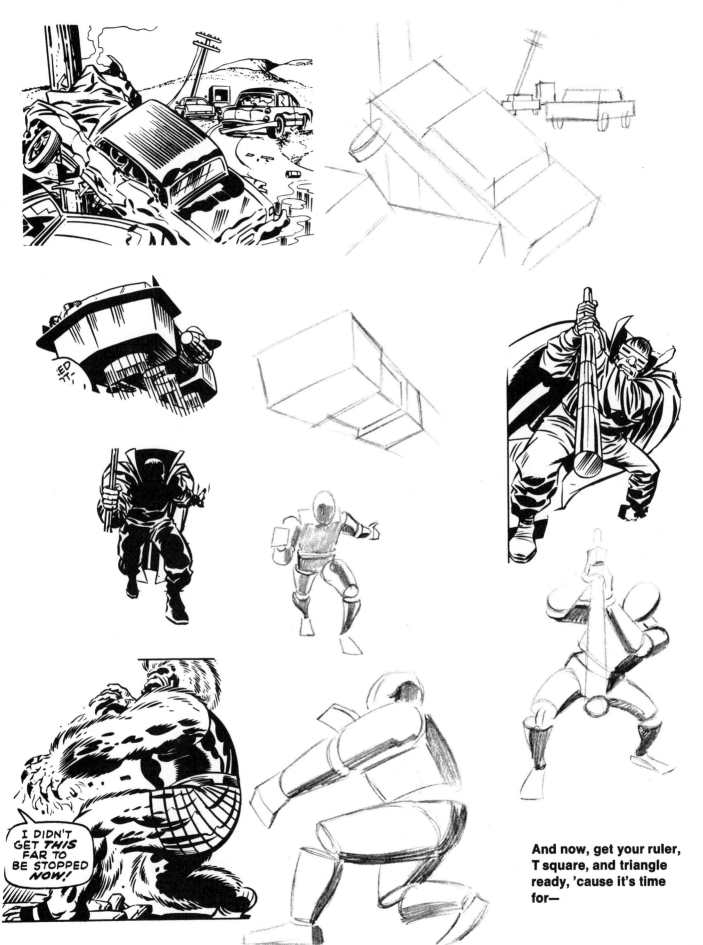

And now, get your ruler, T square, and triangle ready, 'cause it's time for—

THE POWER OF - PERSPECTIVE!

Just as FORM is all-important in making an object look real, so is PERSPECTIVE vitally necessary in making a scene look accurate—in making things appear to be correctly placed in the foreground, background, and all the places in between.

It isn't an easy subject, but you've got to master it in order to draw a comic strip—and we promise to make it as simple and as clear as we can. (And, if it's any consolation, it's just as tough for us to explain as it is for you to learn!)

So, since we're all in this thing together, let's go!

As usual, we'll study the pix on the page opposite. And this time there are two new words you've got to make a part of your conscious and subconscious vocabulary. The words are HORIZON LINE.

Basically, the *horizon line* simply represents the viewer's eye level— that is, the spot in the picture where your own eyes would be if you were there observing the scene.

Let's start with some little examples. Notice the cube on the first line of drawings (A). If you take it and turn it so that we're looking at it head-on (B), you'll see that the two side lines on top seem to be coming together, the way train tracks appear to come together as they recede farther into the distance. Okay then, let's continue drawing those two lines until they meet (C). The point at which they meet is the natural *horizon line,* and is consequently our own eye level. This is called ONE-POINT PERSPECTIVE because the perspective lines converge upon the one single point.

However, if we turn the cube and then follow the converging lines to their ultimate meeting place, we get a TWO-POINT PERSPECTIVE (D)— and I'm not gonna insult your intelligence by telling you why we've changed its name! Incidentally, you'll notice that the cube is below the *horizon line* and therefore below your own eye level.

In figure (E) we've merely redrawn the cube exactly at your eye level, while in figure (F) we've drawn it a third way, showing how to put it above eye level.

Study it awhile. It's not as complicated as it may sound, honest!

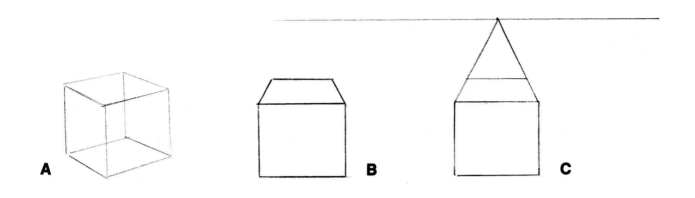

A

B

C

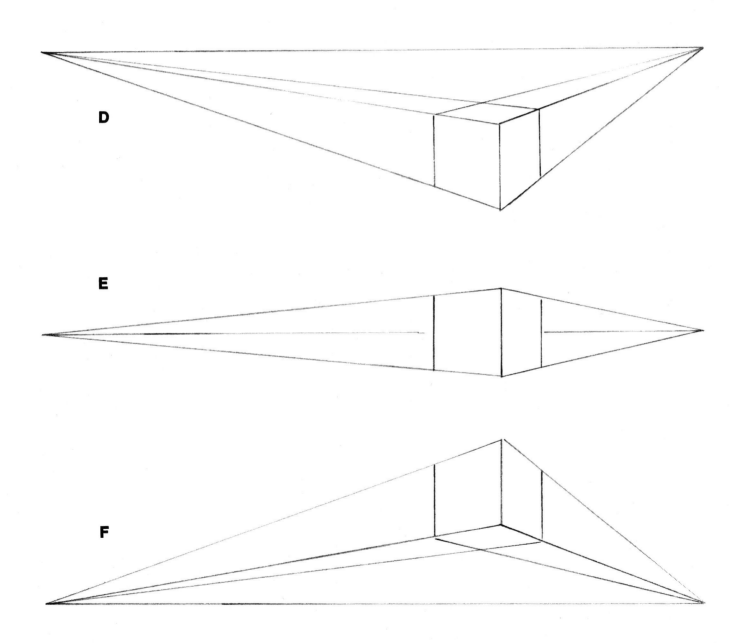

D

E

F

Here, just because Johnny hates to let his ruler go to waste, he's given you a couple more examples showing how the principles of perspective apply to any street scene.

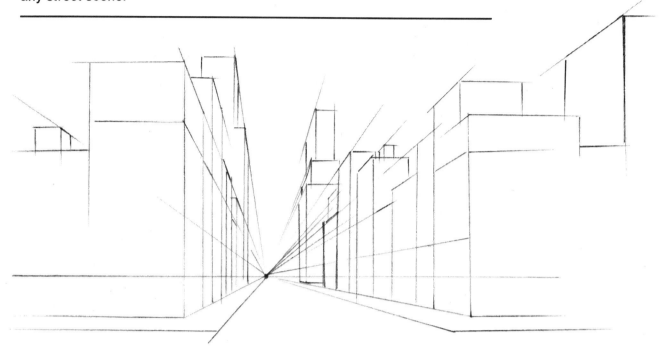

In this first drawing, despite the size of the scene and the number of buildings, you'll notice that everything converges towards one point; therefore it's a ONE-POINT PERSPECTIVE.

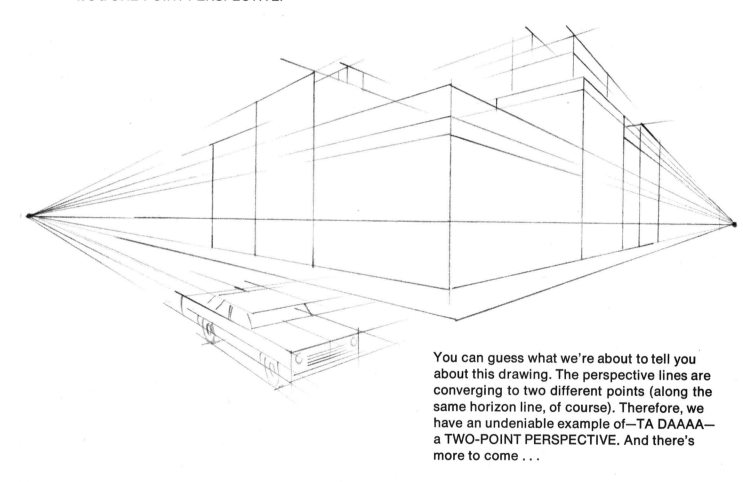

You can guess what we're about to tell you about this drawing. The perspective lines are converging to two different points (along the same horizon line, of course). Therefore, we have an undeniable example of—TA DAAAA—a TWO-POINT PERSPECTIVE. And there's more to come . . .

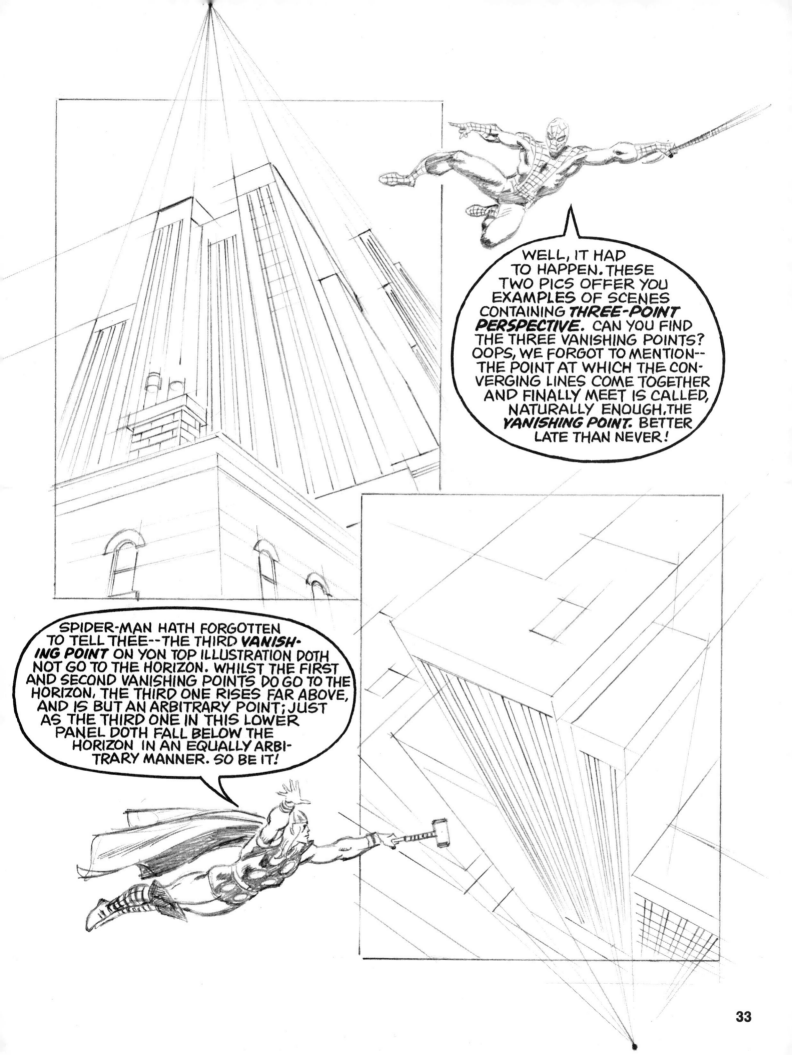

33

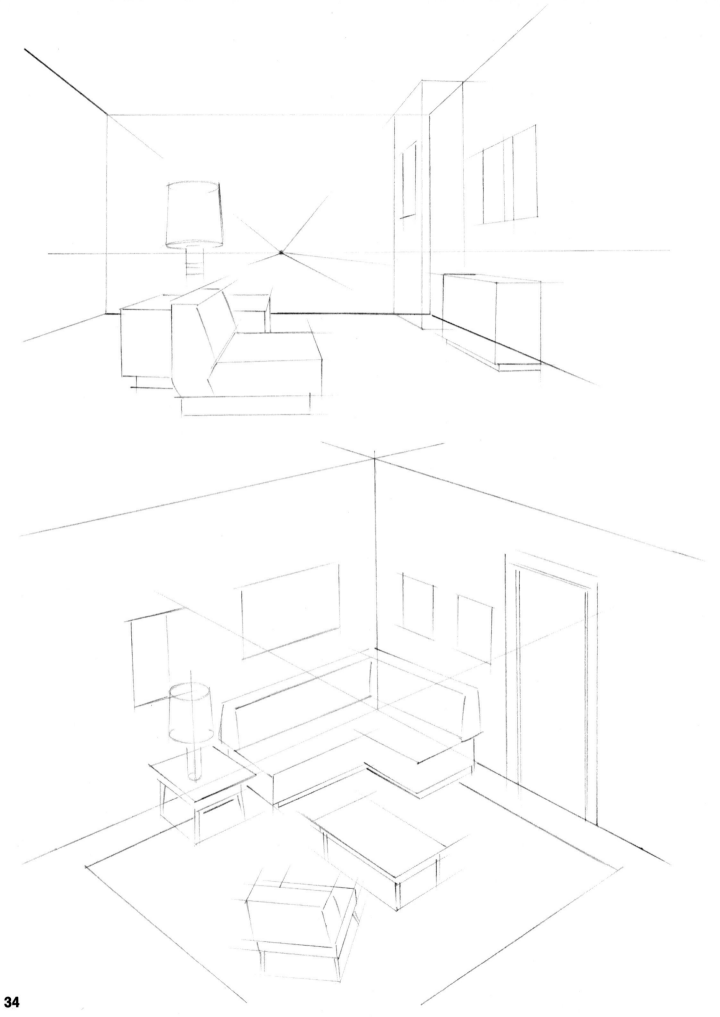

● Let's say you want to draw the inside of a room. Sounds simple, huh? But what about the furniture? You want it to look natural, to look as if it belongs, and most important of all, to look as if some of the pieces aren't floating in space. They have to seem accurate and realistic in relation to each other. Well, that's what perspective is all about.

● In the two illustrations on the facing page, notice how John makes use of his eye level (horizon line) and his vanishing points in order to have everything in the correct perspective. No matter where the viewer's eye level may be, everything falls into place pleasingly because the perspective is correct.

● And, did you notice the way the chair at the bottom of the lower pic is angled (turned) differently than the other pieces of furniture, so that it goes to different vanishing points? This gives us a third and fourth vanishing point on the same horizon line.

● If it seems awfully complicated to you, don't worry. Johnny had to explain it to me about a half-dozen times—and I'm still wrestling with most of it! Anyway, let's go to the next page and tackle a problem or two . . .

Okay. First we'll consider some explanatory diagrams, then we'll see how they apply to pictures we might use in our magazines.

One of the main purposes of our study of perspective is to allow us to tilt objects, to twist them around and turn them without making them seem distorted or incorrect. These diagrams demonstrate how it's done in the very simplest way. So, here we go . . .

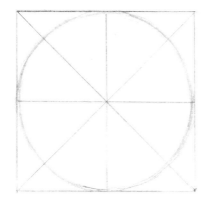

We all know that a perfect circle will fit perfectly within a perfect square.

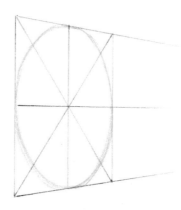

But, if we change the angle (the position) of the square, then see how the circle must change also. See how it becomes an oval.

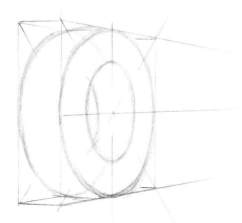

Now then, if we draw a cube (two squares in perspective, side-by-side), and then draw two ovals within the squares, and connect the ovals, we end up with a wheel—drawn in perspective.

Just thought you'd like to see how to divide a square shape in two—in the proper perspective. Simply draw straight lines from corner to corner, as shown. The exact center point is where the two lines meet. Once you've found your perfect center point—in perspective—you know where to do the dividing.

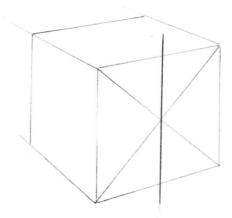

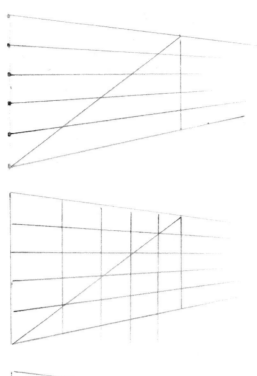

Suppose you want to divide a wall into five equal parts, but to complicate the process the wall is drawn in perspective (with lines converging towards a distant vanishing point). You merely use the same procedure we demonstrated in example #2 above—mark off five equal divisions on the side of the wall and then draw a straight line from corner to corner.

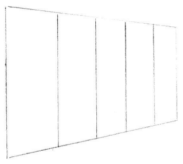

Your points of division will be found exactly where the lines cross.

Erase the original guide lines, and you end up with your five equal vertical divisions, all in the correct perspective.

Now then, we just know that you've been waiting all your life for a chance to draw a checkerboard floor in perspective. Here's how.

—Draw your basic square shape, at any angle you wish.
—On a line parallel to the bottom of the drawing, mark off as many squares as you wish, equally divided.
—From those points, now draw lines extending towards the vanishing point.
—Add your diagonal line, and where it crosses the lines you've originally drawn, you have your exact division points for perfect squares in perspective.

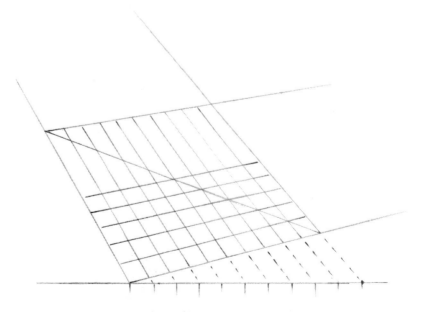

Since you've been such a good sport about the dull stuff, now let's go to the next page and see what bearing all this has on some zingy comicbook drawings . . .

Now, when we mention that this drawing is based on THREE-POINT PERSPECTIVE, you'll know what we mean, won't you? Also, it's a WORM'S-EYE VIEW, right? Right!

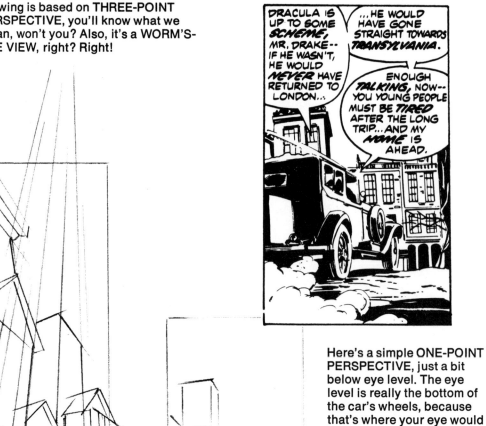

Here's a simple ONE-POINT PERSPECTIVE, just a bit below eye level. The eye level is really the bottom of the car's wheels, because that's where your eye would be if you were actually on the scene. See how it all begins to come together?

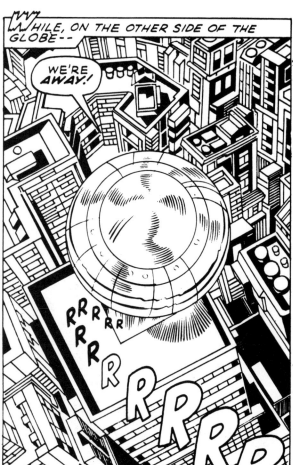

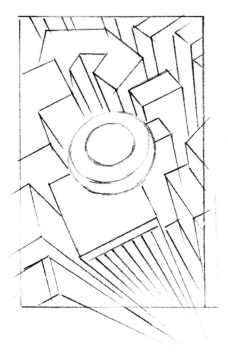

By now we don't even have to tell you that this is obviously a THREE-POINT PERSPECTIVE bird's-eye view—but we'll just mention it anyway because we need the exercise!

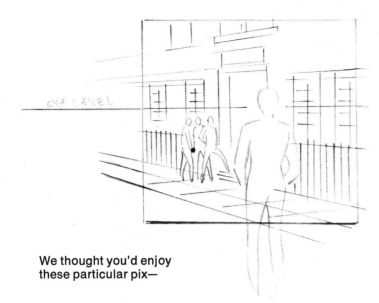

We thought you'd enjoy
these particular pix—

—because they show
how we put the figures
themselves into the
proper perspective in
typical Marvel scenes.

Pay particular attention to where the eye
level is in each panel, as well as the location
of the various vanishing points.

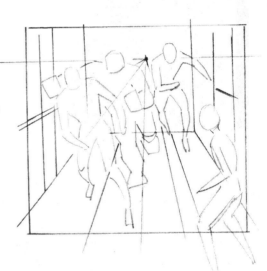

LET'S STUDY- THE FIGURE!

This is it, gang! This is what you've been waiting for! The preceding sections gave the basics you need—the cereals and vegetables. But here's where you get to the main course —and the dazzling desserts!

● There might be something more important than figure drawing in comicbook artwork, but we sure don't know what it is! Everything is based on how you draw the characters: the heroes, villains, and the never-ending hordes of supporting stars. Superhero comicbooks are the stories of people, period! And we're going to try to teach you everything you ought to know about drawing those people and drawing them as dramatically and heroically as possible.

● Let's start with an average Joe, like you or me. Most average guys are about six-and-a-half heads tall. But take a look at this sketch of Reed Richards. Notice that he's eight-and-three-quarters heads tall. If we draw a hero he's got to look like a hero—he should be of heroic proportions. Unfortunately, the normal six-and-a-half-head-tall proportions would make him seem somewhat dumpy when drawn in a Marvel mag.

● Needless to say, we also make the shoulders good and wide, and the hips real narrow. Naturally, as we're soon about to see, the male is drawn much more angular than the female.

● Another good point to remember is—the elbows fall just a little bit below the waist. This is true of both men and women.

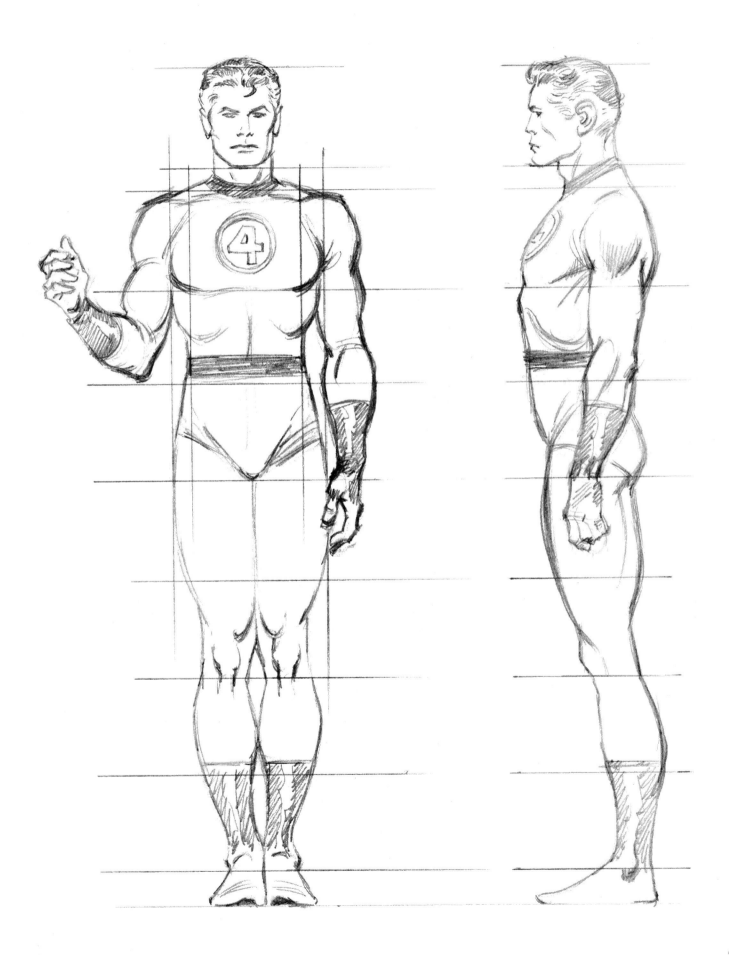

● And, speaking of women—where would Reed Richards be without his stunning Sue?

● Notice that she too is eight-and-three-quarters heads tall, with her hips much wider in relation to her shoulders than they would be on a male.

● Obviously, we do not emphasize muscles on a female. Though we assume she's not a weakling, a woman is drawn to look smooth and soft as opposed to the muscular, angular rendition of a man.

● We've also found that it's preferable to draw a female's head slightly smaller than a male's. In fact, she's generally drawn somewhat smaller all over, except for the bosom.

● As a guide, you might remember that the hand (on both male and female) always falls mid-thigh on the body when the figure is standing.

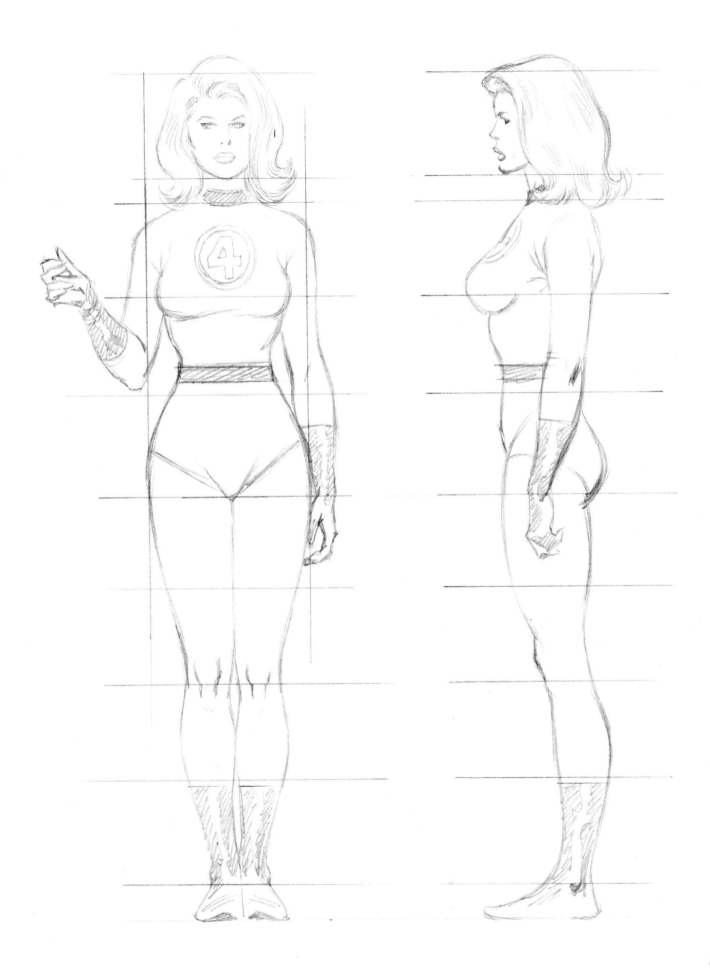

The main purpose of this illo (we'll save our publisher a fortune in typesetting by not spelling out the whole word "illustration"! Hope he appreciates it) is to show the difference between the way we might draw a normal, nice-looking male and a heroically proportioned superhero.

Note that the superhero is larger, with broader shoulders, more muscular arms and legs, a heavier chest, and even a more impressive stance. There's nothing weak-looking about the fella next to Captain America, but a superhero simply has to look more impressive, more dramatic, more imposing than an average guy.

Perhaps the most important single point to remember is that you should always slightly exaggerate the heroic qualities of your hero, and attempt to ignore or omit any negative, undramatic qualities.

But, what about the villains? Glad you asked. Next page, please . . .

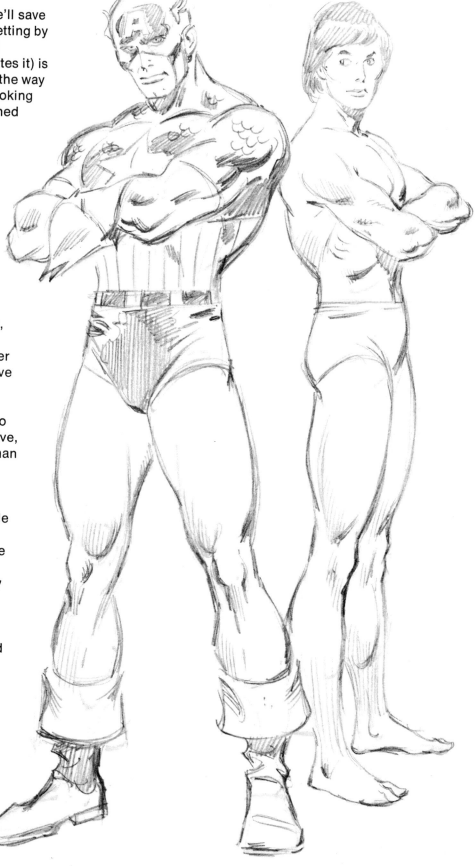

Wouldja believe that virtually the same rules apply to the villains as to the heroes? (When it comes to drawing them, at any rate!)

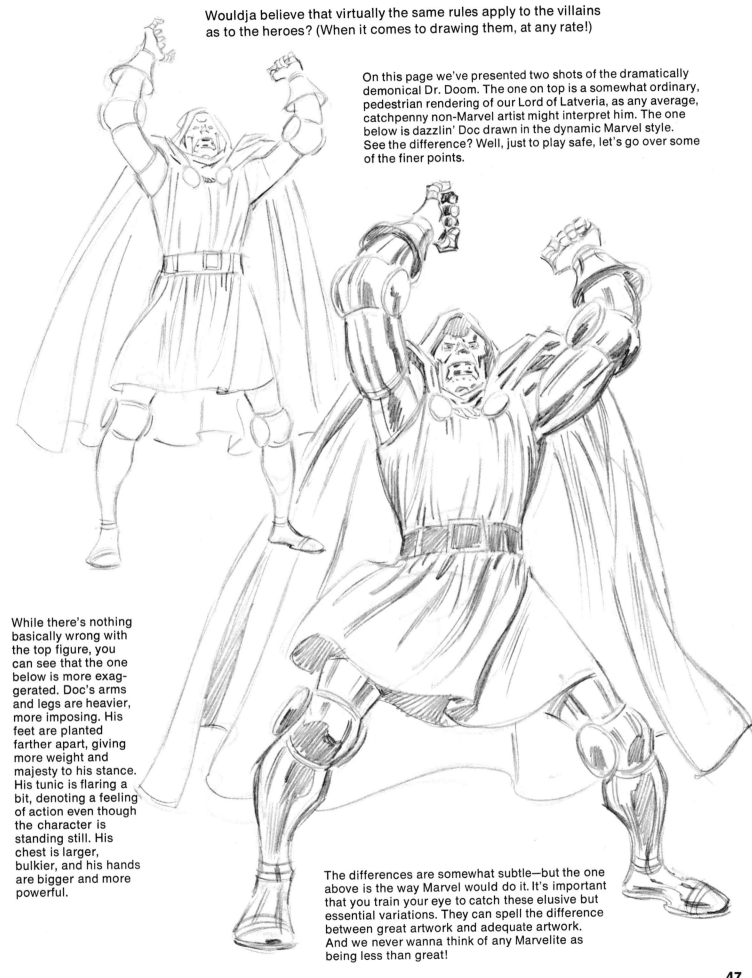

On this page we've presented two shots of the dramatically demonical Dr. Doom. The one on top is a somewhat ordinary, pedestrian rendering of our Lord of Latveria, as any average, catchpenny non-Marvel artist might interpret him. The one below is dazzlin' Doc drawn in the dynamic Marvel style. See the difference? Well, just to play safe, let's go over some of the finer points.

While there's nothing basically wrong with the top figure, you can see that the one below is more exaggerated. Doc's arms and legs are heavier, more imposing. His feet are planted farther apart, giving more weight and majesty to his stance. His tunic is flaring a bit, denoting a feeling of action even though the character is standing still. His chest is larger, bulkier, and his hands are bigger and more powerful.

The differences are somewhat subtle—but the one above is the way Marvel would do it. It's important that you train your eye to catch these elusive but essential variations. They can spell the difference between great artwork and adequate artwork. And we never wanna think of any Marvelite as being less than great!

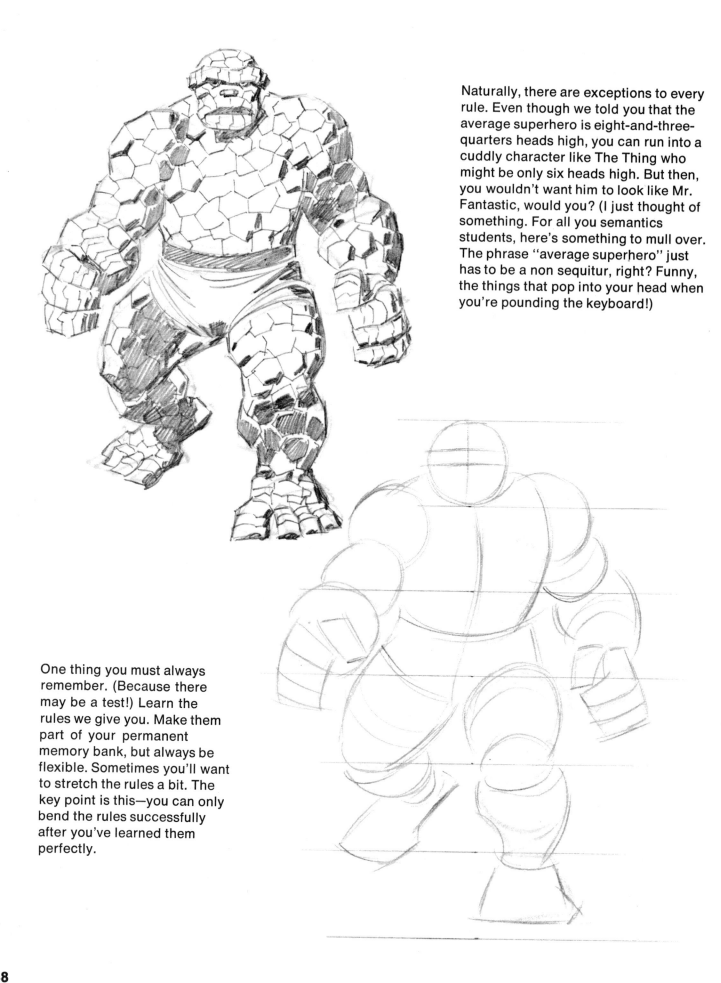

Naturally, there are exceptions to every rule. Even though we told you that the average superhero is eight-and-three-quarters heads high, you can run into a cuddly character like The Thing who might be only six heads high. But then, you wouldn't want him to look like Mr. Fantastic, would you? (I just thought of something. For all you semantics students, here's something to mull over. The phrase "average superhero" just has to be a non sequitur, right? Funny, the things that pop into your head when you're pounding the keyboard!)

One thing you must always remember. (Because there may be a test!) Learn the rules we give you. Make them part of your permanent memory bank, but always be flexible. Sometimes you'll want to stretch the rules a bit. The key point is this—you can only bend the rules successfully after you've learned them perfectly.

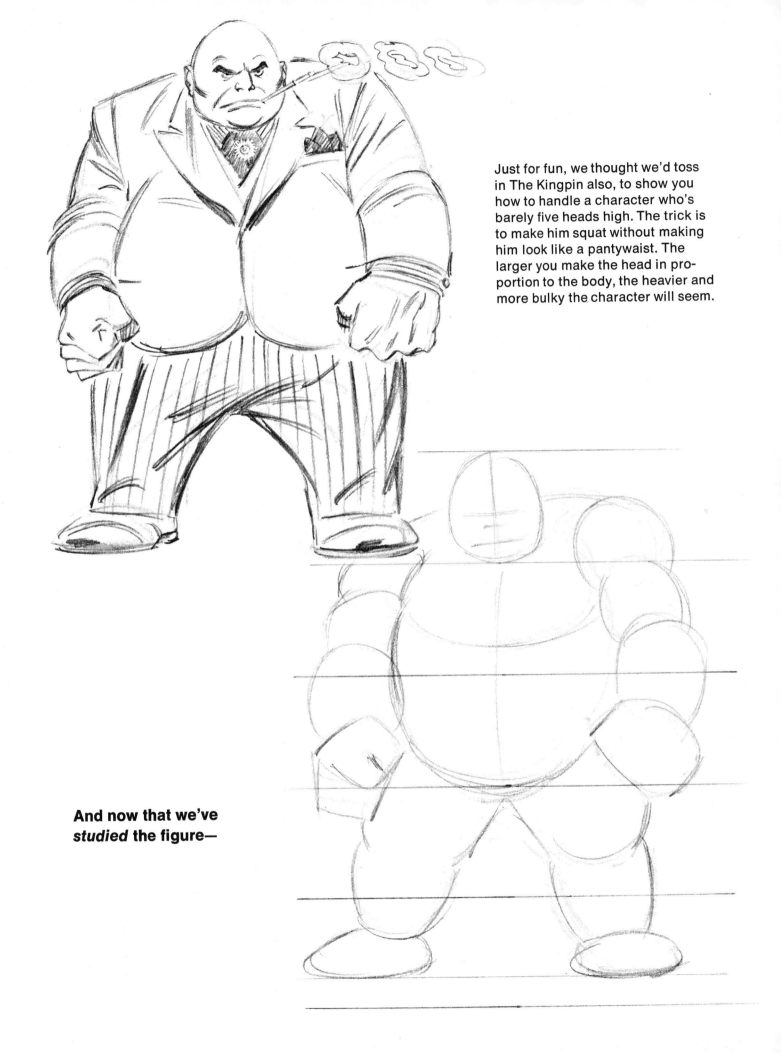

Just for fun, we thought we'd toss in The Kingpin also, to show you how to handle a character who's barely five heads high. The trick is to make him squat without making him look like a pantywaist. The larger you make the head in proportion to the body, the heavier and more bulky the character will seem.

And now that we've _studied_ the figure—

LET'S DRAW THE FIGURE!

This part is dynamite! So let's not waste a second—!

Look, the first thing a fledgling artist needs is self-confidence. And here's the way to get it!

'Most anyone can draw a stick figure. (Even Irving Forbush!) They're simple, they're fun, and most important of all, they're the easiest way for you to get the action and the position you want for your character.

Don't try to do a complete drawing all at once. Spend all the time you can doodling with stick figures. Stay with them for hours, days, weeks if you feel like it, until they become second nature to you—until you can create virtually any pose you can think of.

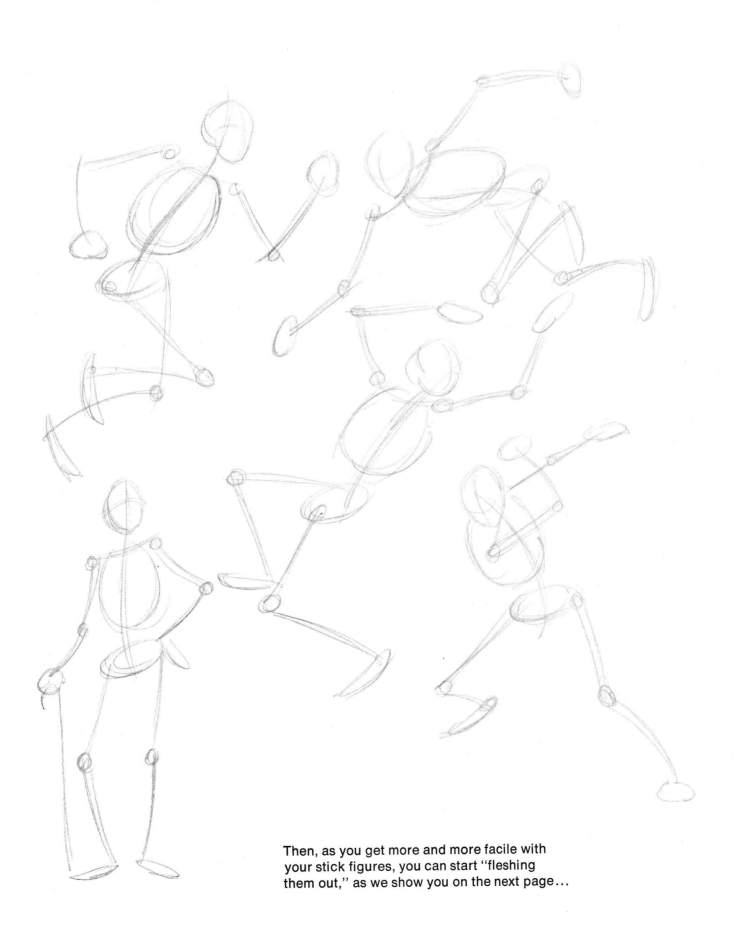

Then, as you get more and more facile with your stick figures, you can start "fleshing them out," as we show you on the next page...

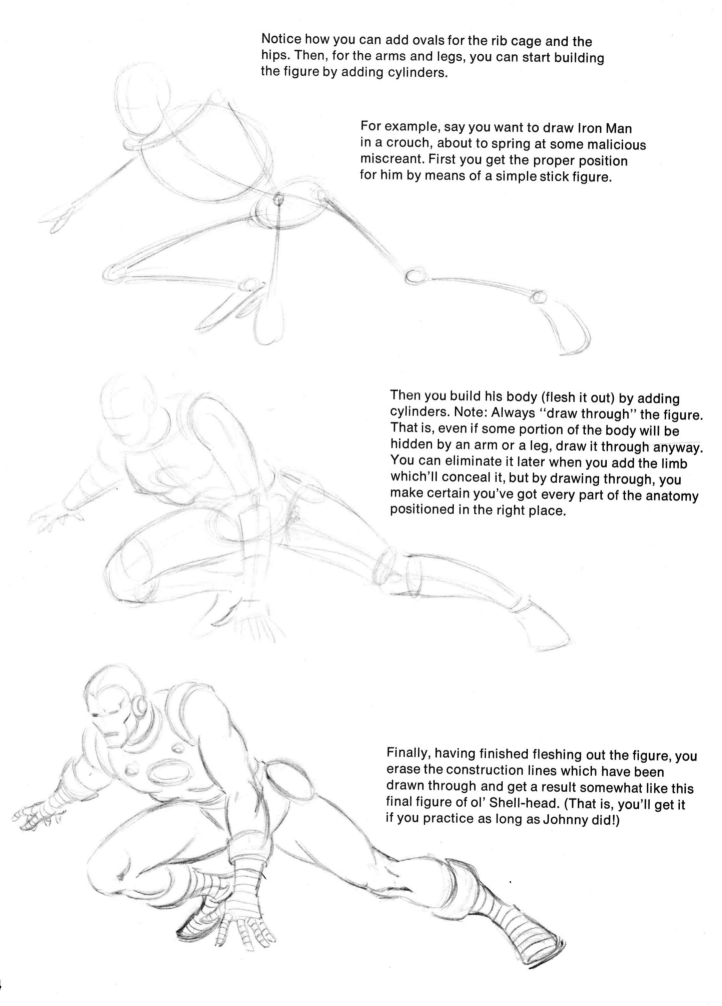

Notice how you can add ovals for the rib cage and the hips. Then, for the arms and legs, you can start building the figure by adding cylinders.

For example, say you want to draw Iron Man in a crouch, about to spring at some malicious miscreant. First you get the proper position for him by means of a simple stick figure.

Then you build his body (flesh it out) by adding cylinders. Note: Always "draw through" the figure. That is, even if some portion of the body will be hidden by an arm or a leg, draw it through anyway. You can eliminate it later when you add the limb which'll conceal it, but by drawing through, you make certain you've got every part of the anatomy positioned in the right place.

Finally, having finished fleshing out the figure, you erase the construction lines which have been drawn through and get a result somewhat like this final figure of ol' Shell-head. (That is, you'll get it if you practice as long as Johnny did!)

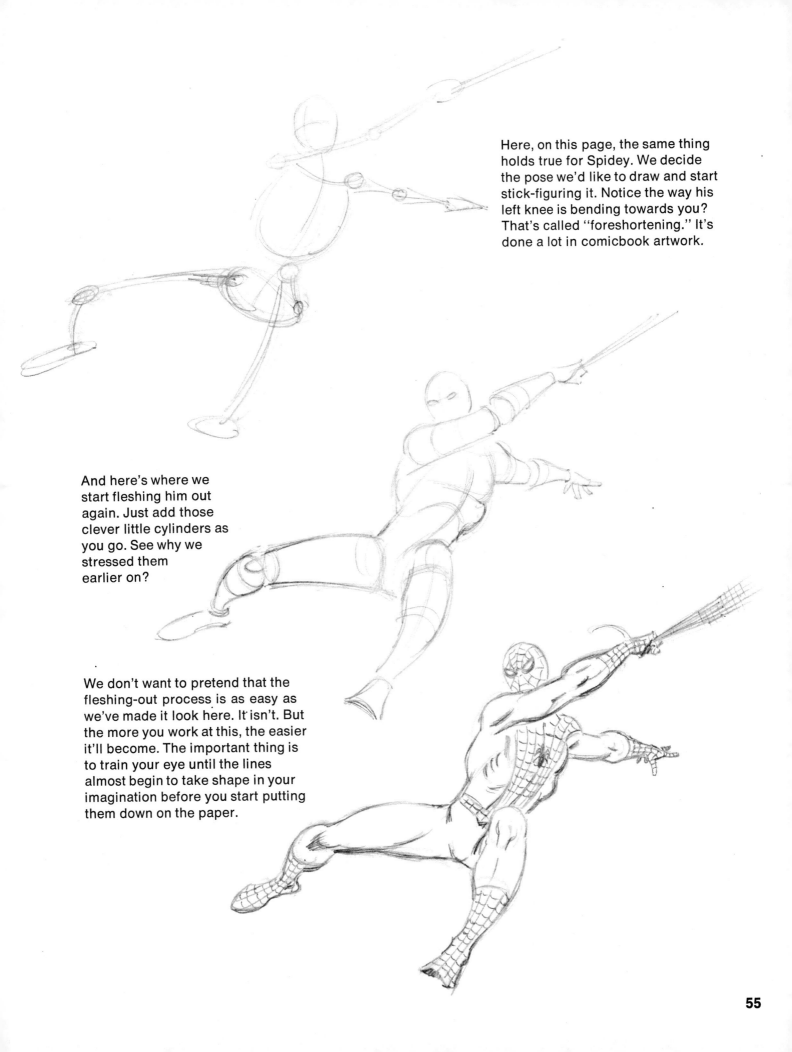

Here, on this page, the same thing holds true for Spidey. We decide the pose we'd like to draw and start stick-figuring it. Notice the way his left knee is bending towards you? That's called "foreshortening." It's done a lot in comicbook artwork.

And here's where we start fleshing him out again. Just add those clever little cylinders as you go. See why we stressed them earlier on?

We don't want to pretend that the fleshing-out process is as easy as we've made it look here. It isn't. But the more you work at this, the easier it'll become. The important thing is to train your eye until the lines almost begin to take shape in your imagination before you start putting them down on the paper.

Now then, for those of
you who've mastered the
cubes and its cousins,
and for those who really
understand the construc-
tion of the human figure,
there's another approach
to forming the body. It's
as basic and obvious as
the simple process of—
scribbling! So, if you're a
more advanced student,
you may get a kick out
of this . . .

Never underestimate the im-
portance of scribbling. After
you've started with your stick
figure, build it up by scribbling
—as in the drawings on this
page. As John explains it, it's
like being a sculptor and
building a figure with clay.
You just keep adding these
loose little lines until the
figure starts taking shape.

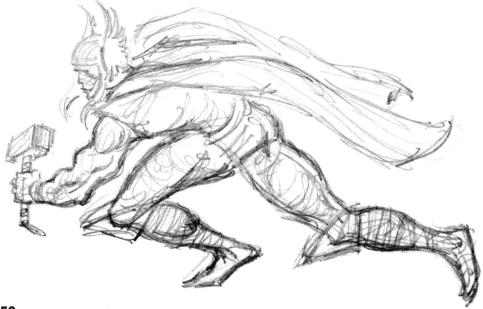

Another important thing about
scribbling is that it helps you
to loosen up and get a feeling
of movement and action. Do
your scribbling lightly, and try
to train your eye to spot the
lines that are correct and to
reject the ones that aren't.
Then, as you continue to mold
the figure with your pencil, you
emphasize the important lines
and eventually lose the others.

56

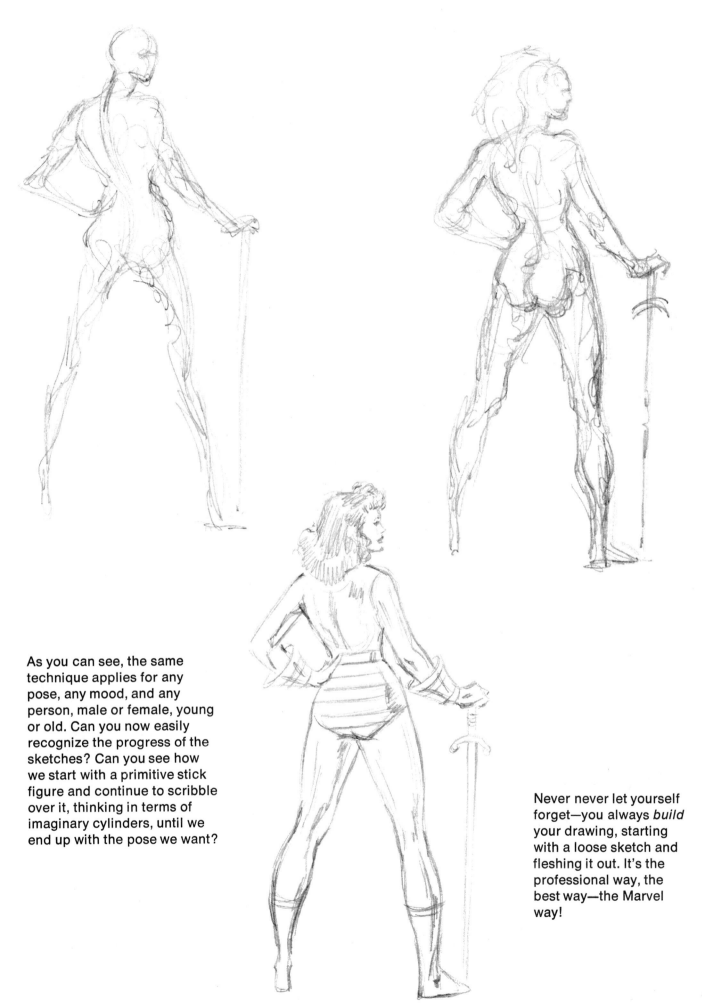

As you can see, the same technique applies for any pose, any mood, and any person, male or female, young or old. Can you now easily recognize the progress of the sketches? Can you see how we start with a primitive stick figure and continue to scribble over it, thinking in terms of imaginary cylinders, until we end up with the pose we want?

Never never let yourself forget—you always *build* your drawing, starting with a loose sketch and fleshing it out. It's the professional way, the best way—the Marvel way!

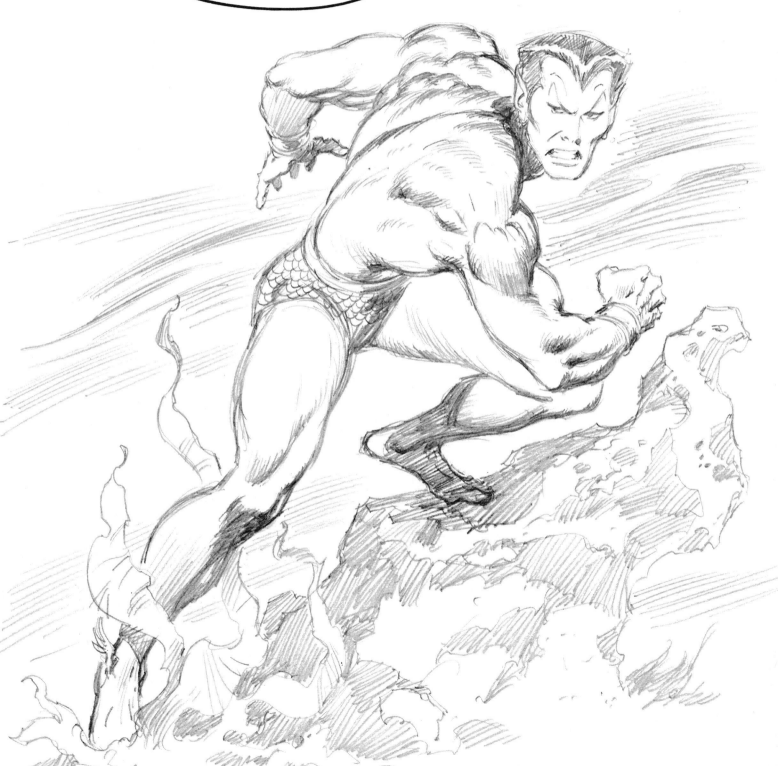

THE NAME OF THE GAME IS- ACTION!

Action! A Marvel specialty! A Marvel Trademark! Sharpen your pencil, pilgrim—here's where we separate the men from the boys!

Just being able to draw the figure is only half the job. When you're drawing comicbook superhero sagas, you've got to be able to move it—to animate it—to put it in action!

Using what you've learned in stick-figure drawing, take a character running, walking, playing ball, or throwing a punch. Draw a series of stick figures, as on the facing page, depicting as many different stages of that action as possible. Familiarize yourself with moving the body; work from one figure into another, slowly, loosely, casually, using as many scribble lines as you wish. Don't try to do a finished drawing, just loosen up, try to feel the action.

Notice how the first drawing and the last one in that particular sequence seem to have the most impact—the most action. In a Marvel story, the artist would use either of those shots rather than the tamer ones in between.

Remember, in these sketches all you need is three or four lines to establish the action. See the two sketches on the bottom of the page? Notice how Johnny caught all the action he wanted in just the fewest of lines—and see how skillfully he was able to build on it. You'll be doing this, too, once you've had enough practice.

Try to exaggerate your action—keep the figure loose, supple, always in motion.

Notice how three or four lines establish the action for you. Once you've got the swing of it, the feel of it, then build upon the figure.

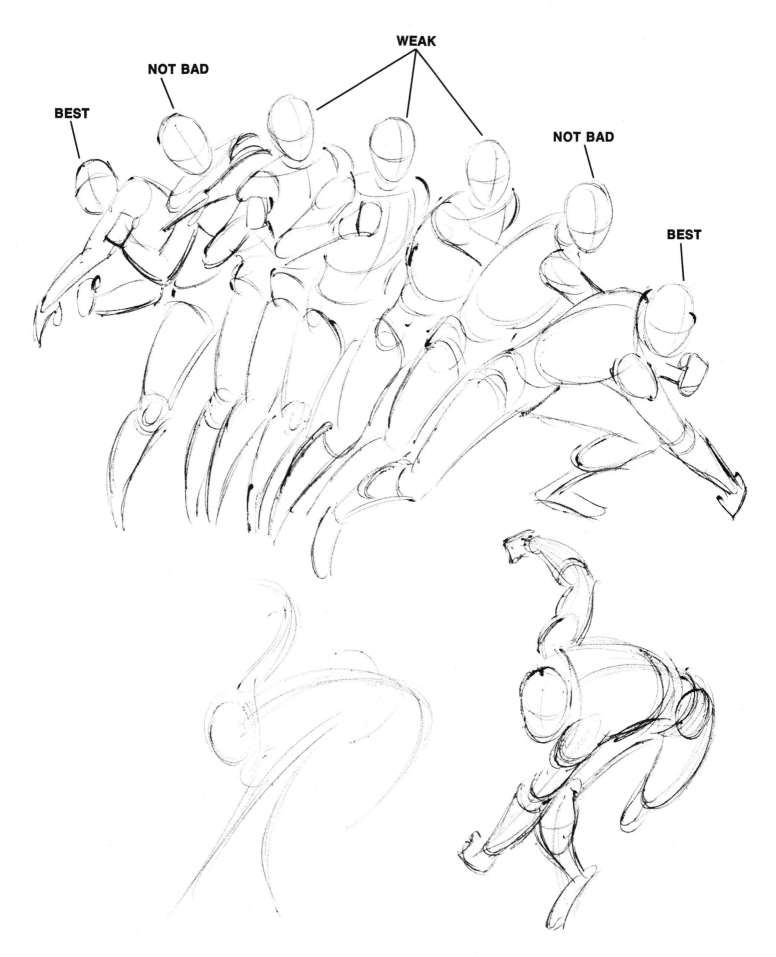

BEST

NOT BAD

WEAK

NOT BAD

BEST

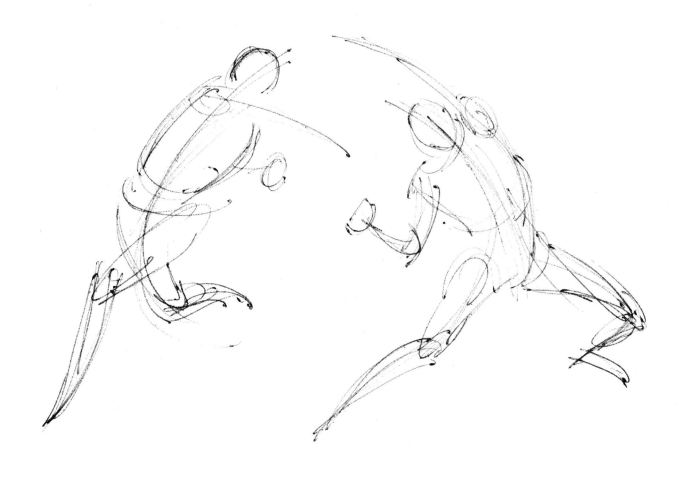

Pay particular attention to the *center line* drawn through the figure
from top to bottom. This line is always drawn first; it gives you the
curve, or the swing, that you want your figure to have.

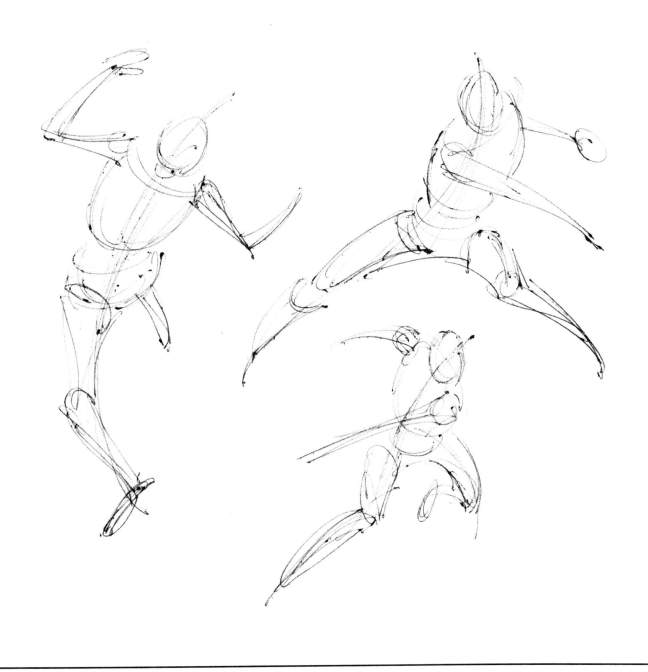

Always remember, every pose has a certain "rhythm" to it. With
this one simple center line you can determine that rhythm and then
start building your entire figure around it.

Now let's study some figures in motion and see which we like and which we don't—and why.

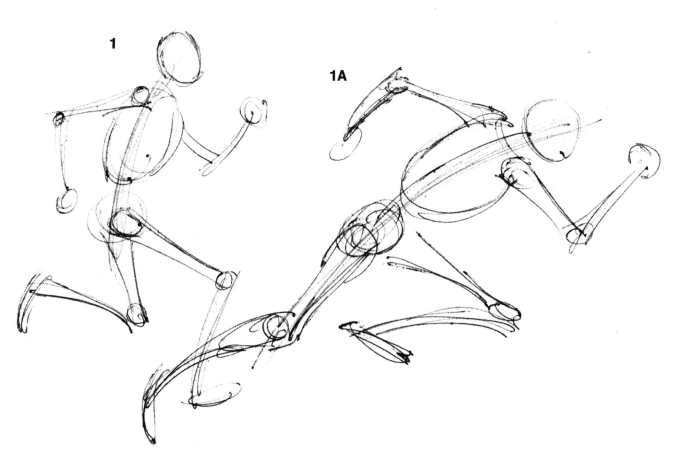

Figures 1 and 1A are both rough sketches of somebody running. But notice how much faster, how much more dramatically, how much more heroically figure 1A is moving. See how his center line has more swing to it, impelling him forward with force and urgency.

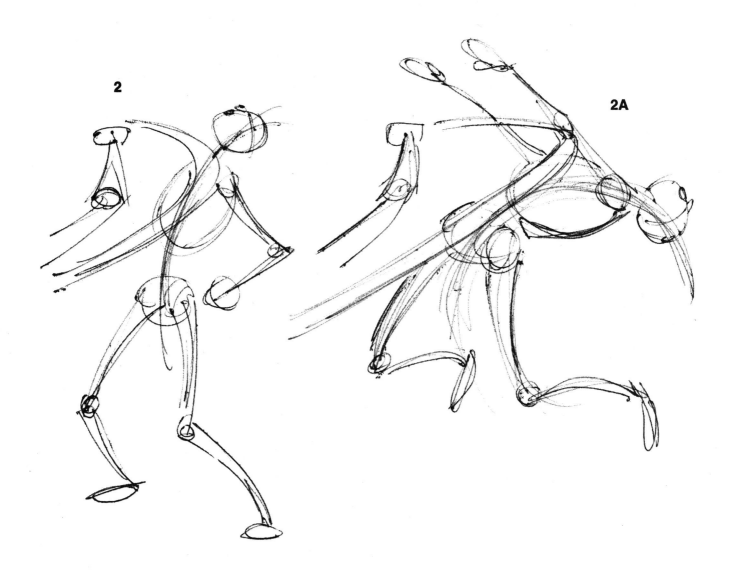

2

2A

Same thing goes for figures 2 and 2A. Both depict a character reacting to a punch in the jaw. While 2 is a perfectly clear, understandable sketch, it simply isn't done in the Marvel style. It doesn't have the vitality, the movement, the sharply curved center line of 2A. See how much looser 2A is—see how the legs are bent and thrusting backwards as the arms jut forward. See how the head follows the center line, completing a graceful, fluid curve. Now that's Marvel!

Even when characters are just standing, the same rules apply. Notice the figures on the facing page . . .

In each case, the smaller figure is okay. But just okay. Not particularly dramatic, not overly heroic, and certainly not very interesting.

Now then, see how the larger figures, which illustrate the same poses, have more drama to them, more heroism, and far more interest.

The variations may not seem to be major, and yet as simple a device as thrusting the head farther forward, or spreading the legs farther apart, can make all the difference in the world. Basically, the smaller figures are perfectly adequate drawings; but the larger ones are Marvel-style drawings!

On the two following pages (68 and 69) you'll find a number of other action sketches which are all pure Marvel. Study them carefully and try to duplicate them. They're simple, loose, free-and-easy, and—although each was done with just a few sketchy lines—they're all excellent examples of how to get that Marvel feeling in even the simplest of drawings.

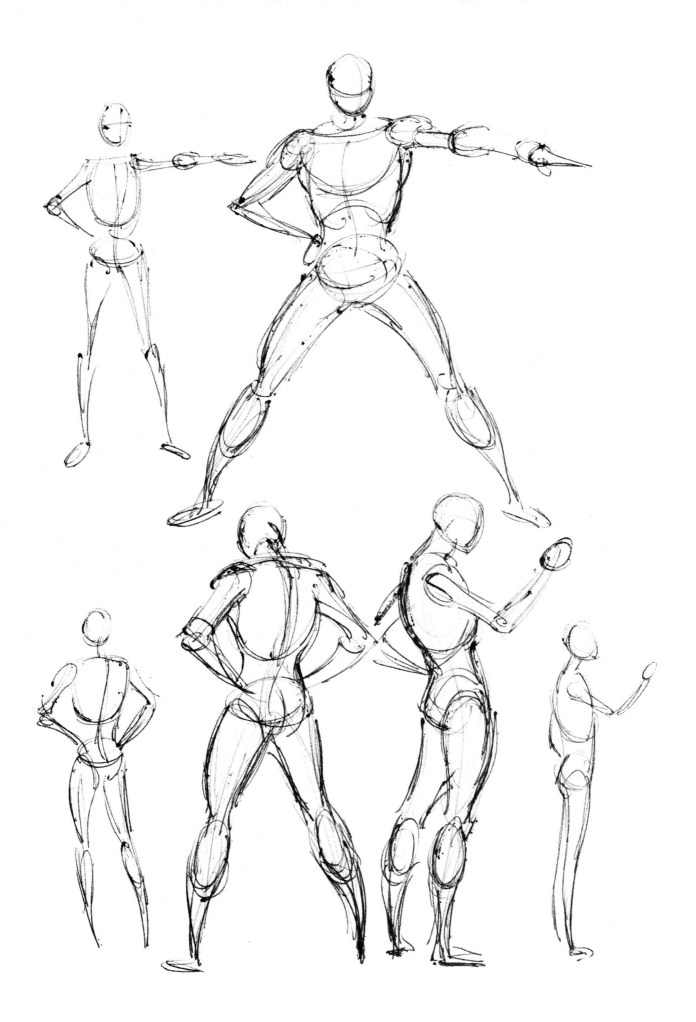

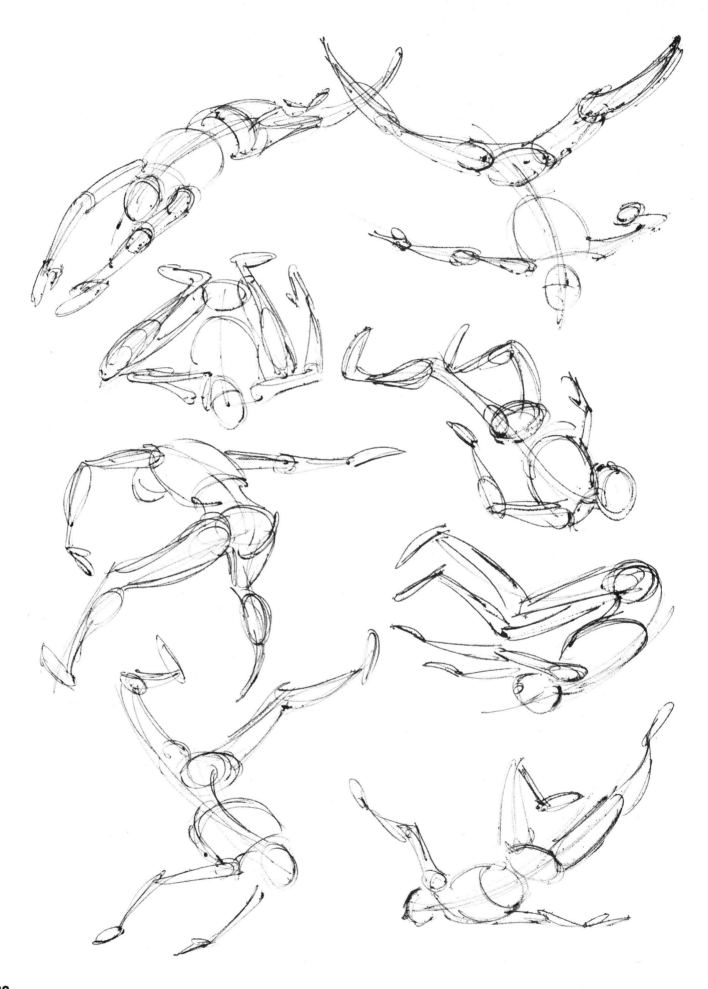

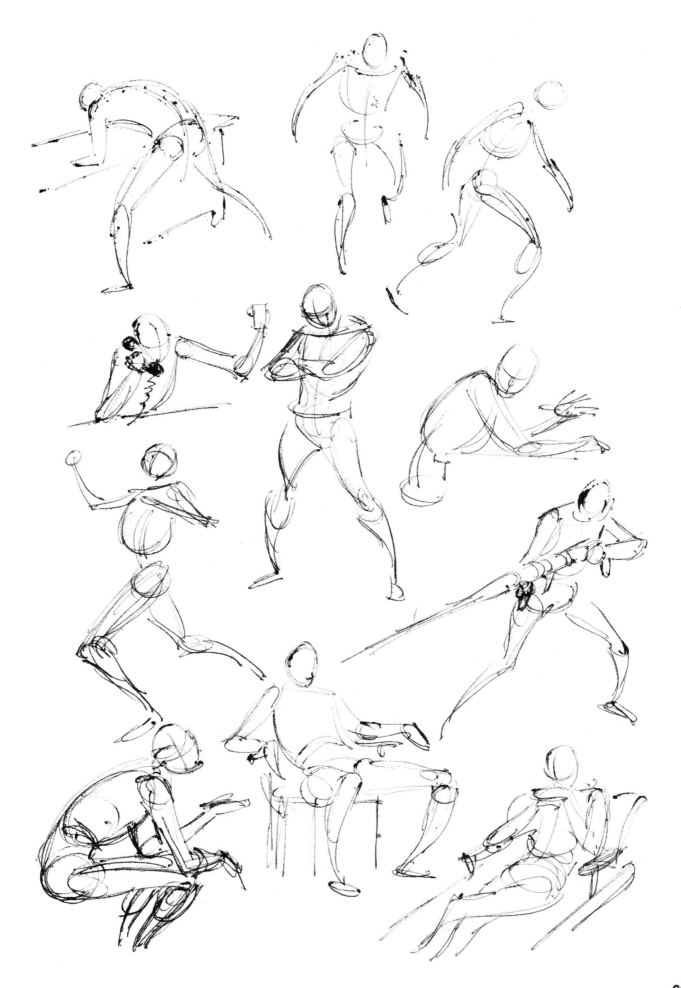

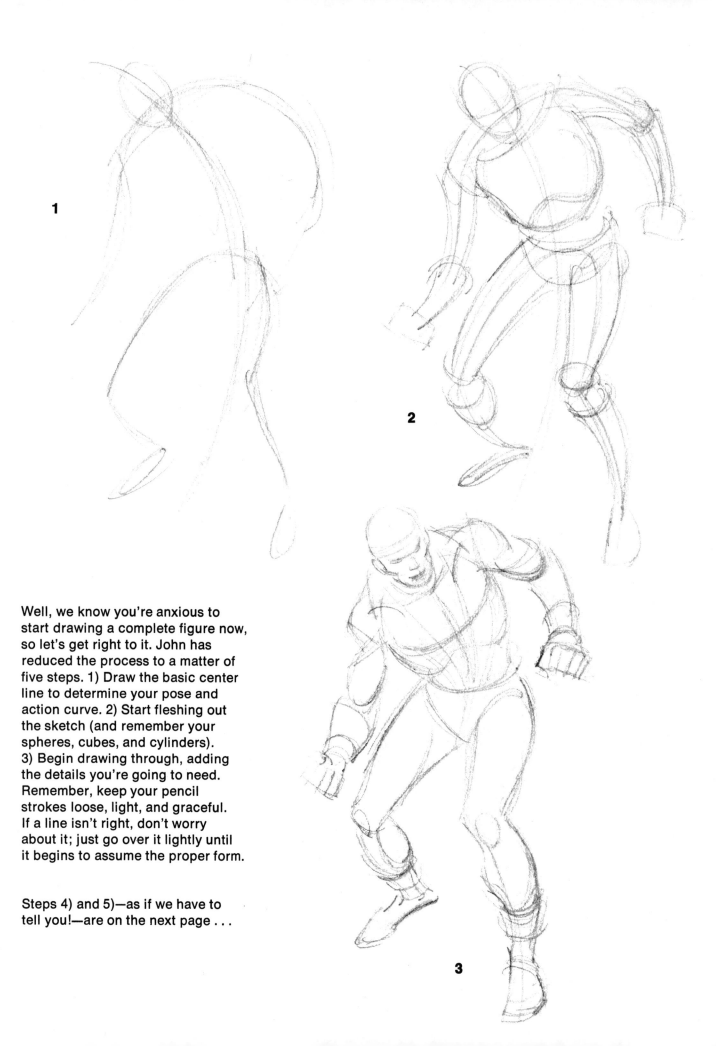

1

2

Well, we know you're anxious to start drawing a complete figure now, so let's get right to it. John has reduced the process to a matter of five steps. 1) Draw the basic center line to determine your pose and action curve. 2) Start fleshing out the sketch (and remember your spheres, cubes, and cylinders). 3) Begin drawing through, adding the details you're going to need. Remember, keep your pencil strokes loose, light, and graceful. If a line isn't right, don't worry about it; just go over it lightly until it begins to assume the proper form.

Steps 4) and 5)—as if we have to tell you!—are on the next page . . .

3

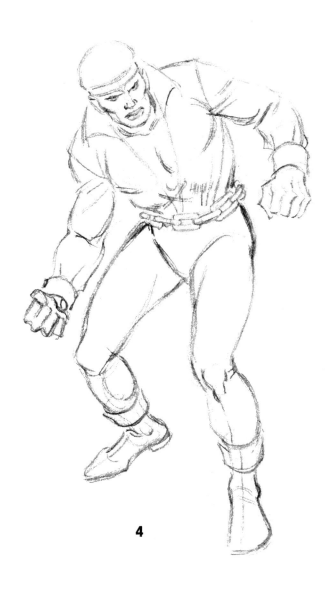

4

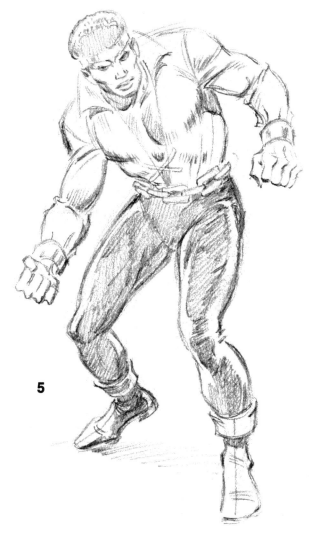

5

4) Voila! After studying all the little sketch lines we've been doodling, we finally select the ones that please us the most and go over them once more, bearing down harder on the pencil. At last the final drawing begins to take shape.

5) In Chapter Two, remember how we added black tones to our various spheres, cubes, and cylinders in order to give them form? Notice how we accomplish the same thing on the human figure. There'll be more about this later—we just wanted to whet your appetite!

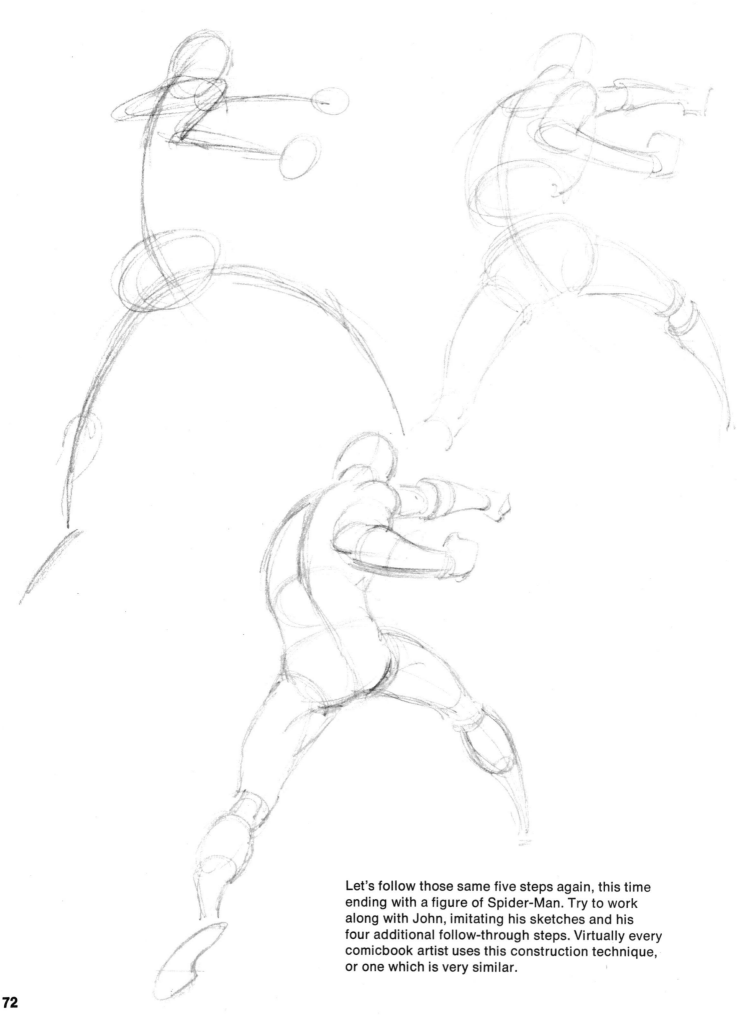

Let's follow those same five steps again, this time ending with a figure of Spider-Man. Try to work along with John, imitating his sketches and his four additional follow-through steps. Virtually every comicbook artist uses this construction technique, or one which is very similar.

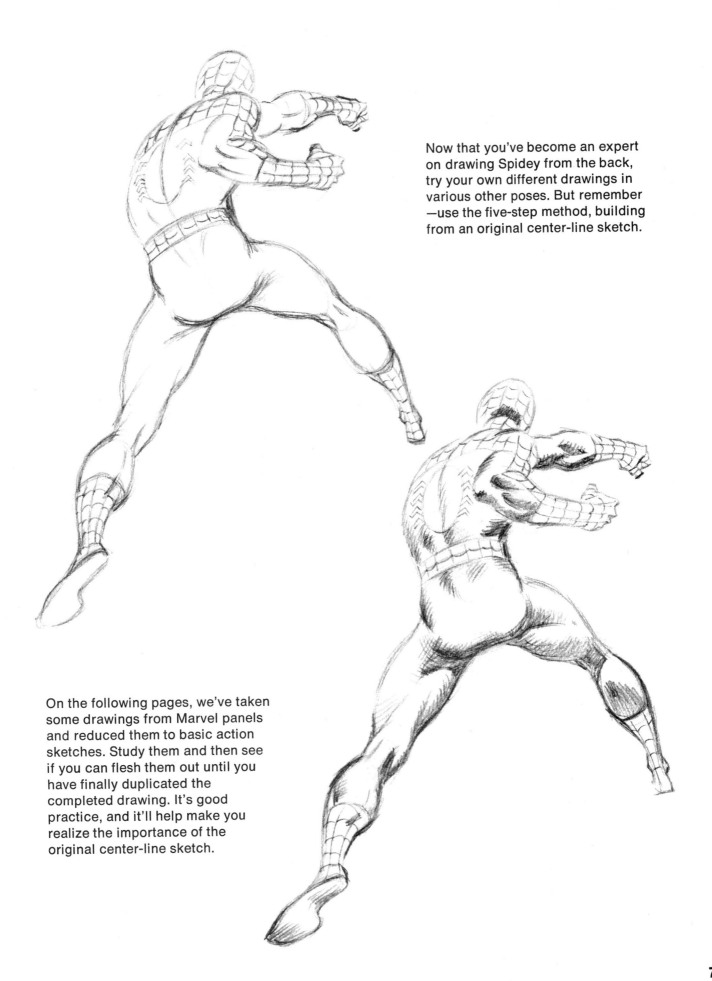

Now that you've become an expert on drawing Spidey from the back, try your own different drawings in various other poses. But remember —use the five-step method, building from an original center-line sketch.

On the following pages, we've taken some drawings from Marvel panels and reduced them to basic action sketches. Study them and then see if you can flesh them out until you have finally duplicated the completed drawing. It's good practice, and it'll help make you realize the importance of the original center-line sketch.

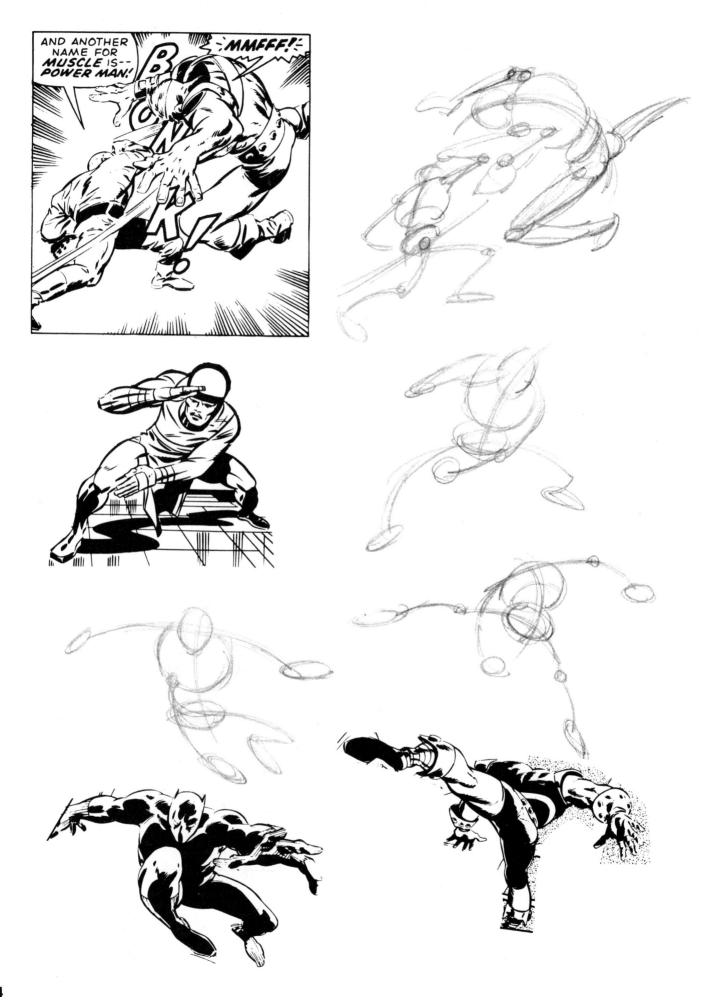

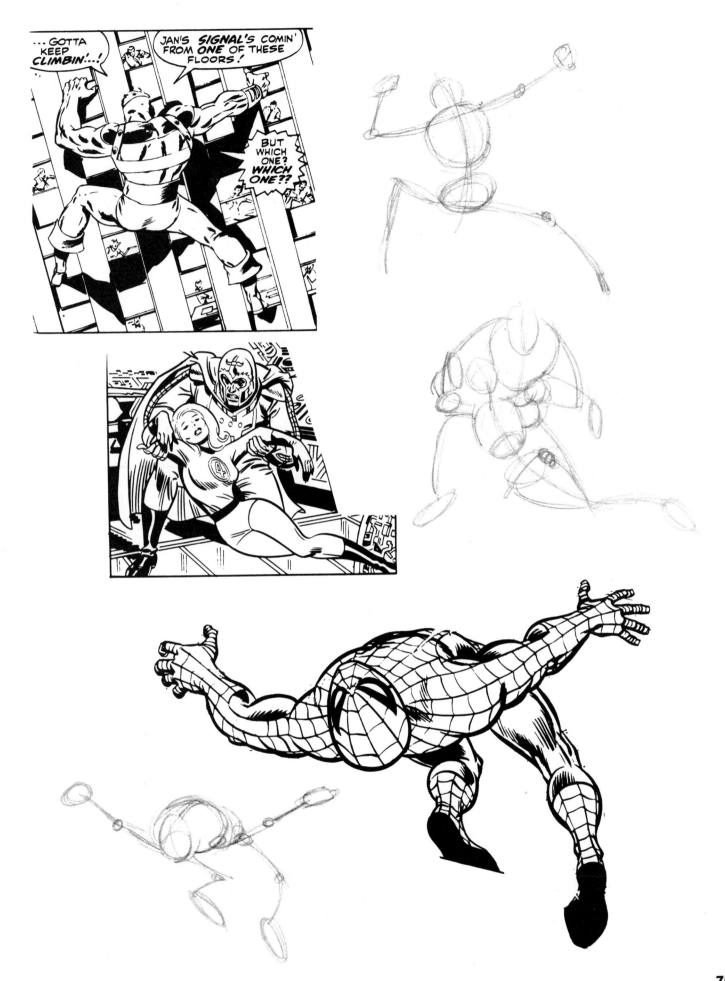

FORESHORTENING!
THE KNACK OF DRAWING THE FIGURE
IN PERSPECTIVE!

This chapter's a short one— but it's vitally important. Take your time with it and make sure you thoroughly understand all the main points. Without a knowledge of foreshortening, all your figures could end up looking like they were drawn on pyramids by the ancient Egyptians!

You hardly ever look at another figure in a flat perspective. There's usually some part of the body that's tilted towards you, or bent back away from you, or angled in some manner or other.

Every competent comicbook artist must know how to deal with this matter of "foreshortening" the body—and you're no exception. Here, once again, our practice with spheres, cubes, and cylinders will stand us in good stead. Using these geometric shapes for the body will make it easier to solve the vital problem of figure foreshortening.

As the pix on the facing page demonstrate, when these shapes are tilted away from your eye they seem to flatten out—or to become shorter. (That's where the word "foreshorten" comes from. The object seems to get shorter as it's tilted towards the "fore.")

Here's a simple experiment you can try. Hold a drinking glass straight up in front of you. Now, tilt it slowly back. See how its body seems to shorten as you do so. That's foreshortening, right?

The same rules apply whether you're above the figure and looking down at it (A), or below it and looking up (B).

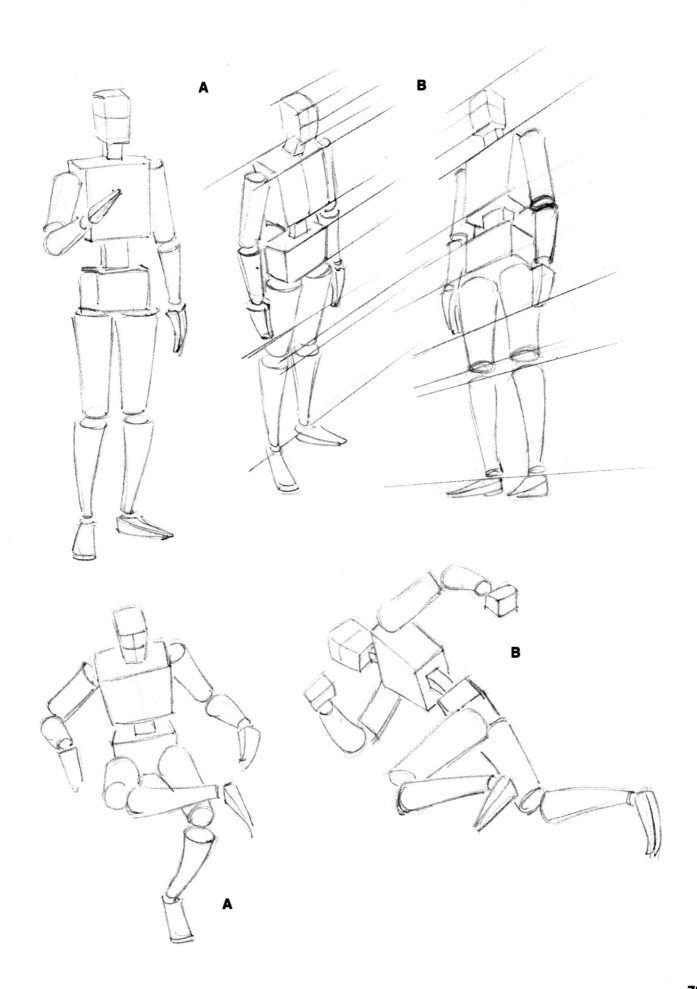

A

B

B

A

79

● As you analyze the figures on the facing page, notice how the cubes and cylinders always *shorten* as they go away from you. As a matter of fact, it might help you to think of the entire figure as a bunch of connected building blocks. The artist (you) has the task of stringing them out and arranging them in the proper position—making sure that they're correctly foreshortened as they tilt away from the viewer's eye.

● On the pages that follow, you'll see examples of various problems in perspective taken from actual drawings which have appeared in Marvel Comics. Next to each drawing, John has sketched the "building blocks" and perspective lines to illustrate how each of the problems was solved by the artist.

● By comparing the finished drawing with the corresponding building-block sketch, you should be able to see how the rules we have given you apply to almost any type of illustration.

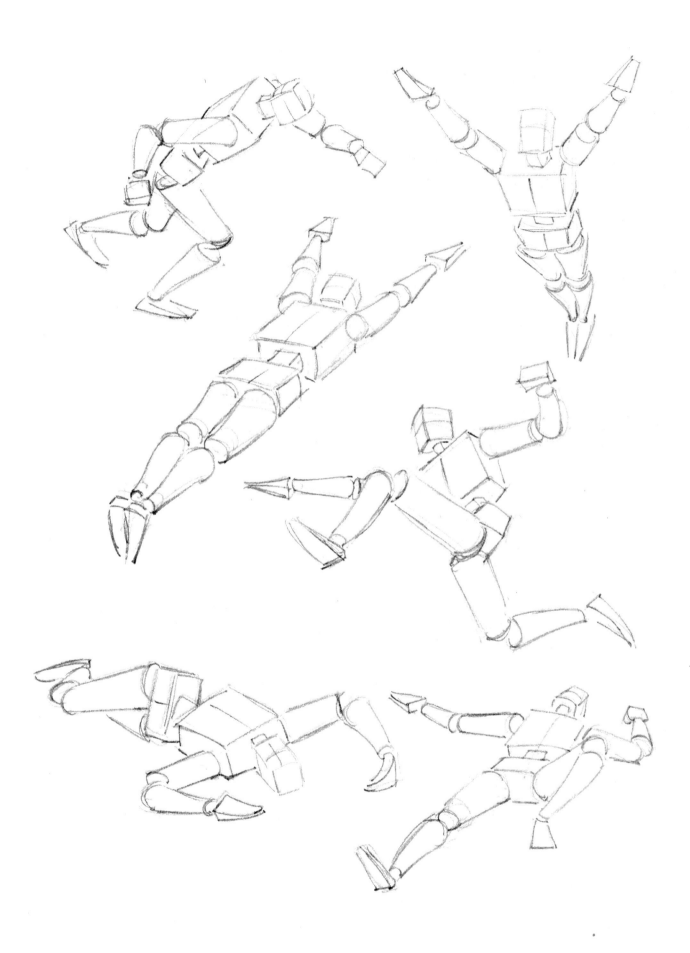

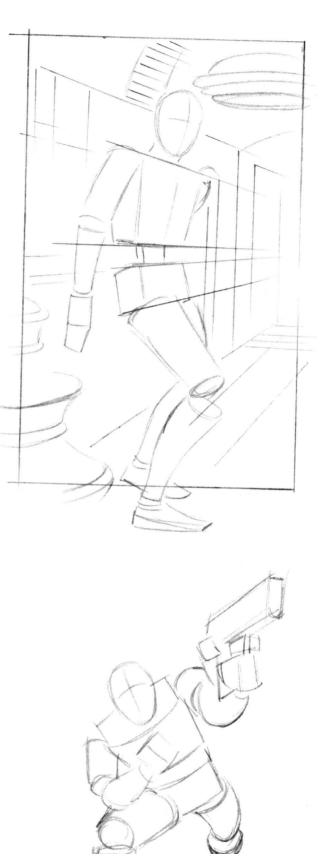

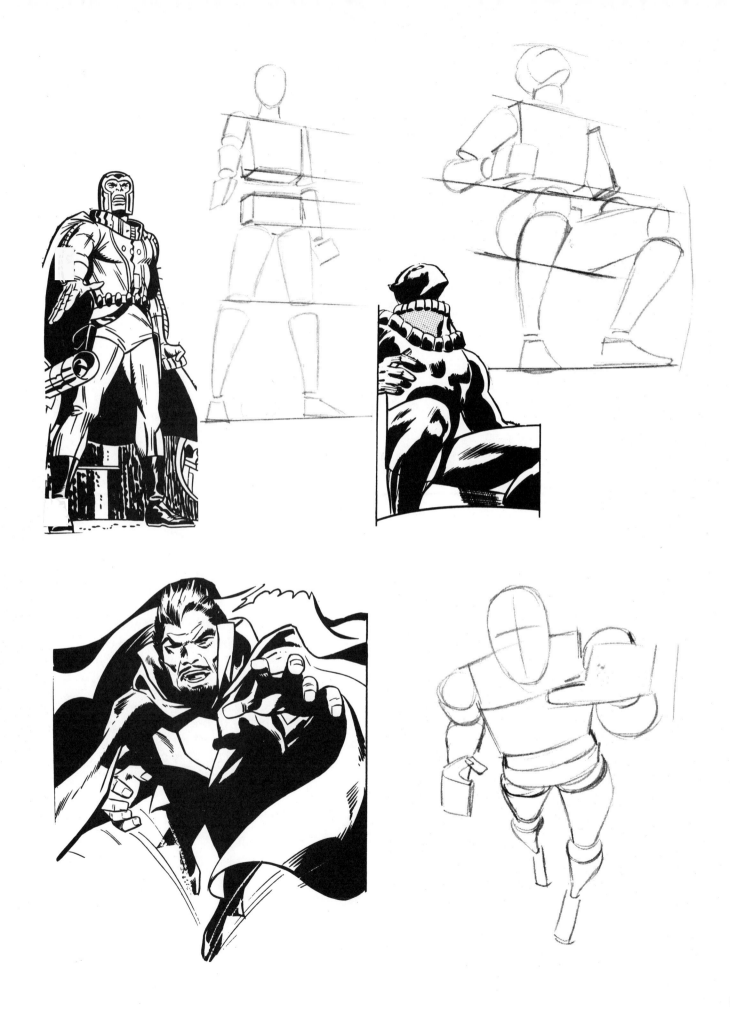

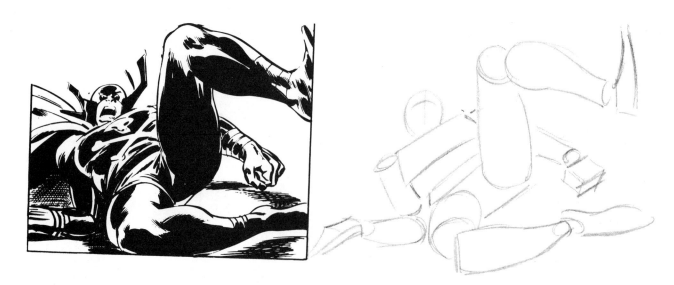

Note the two thighs of our black-garbed bad guy above. Obviously, in real life they'd both be the same size. Yet, in this dramatically foreshortened pose, see how his right thigh seems to have become considerably shorter than his left, because it's tilted at such a severe angle and pointed almost directly at us—as revealed very clearly in the accompanying building-block sketch.

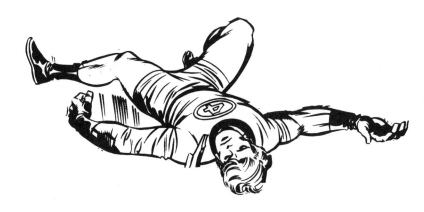

The same goes for the shot of The Thing, on the right-hand side of the facing page. See how very much shorter his left leg seems to be— and his right arm, as well—both because of the extreme angles at which they're drawn. It's this skillful use of foreshortening that makes a figure seem to really come to life as it goes into action on the printed page.

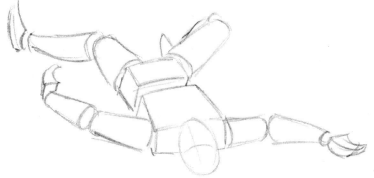

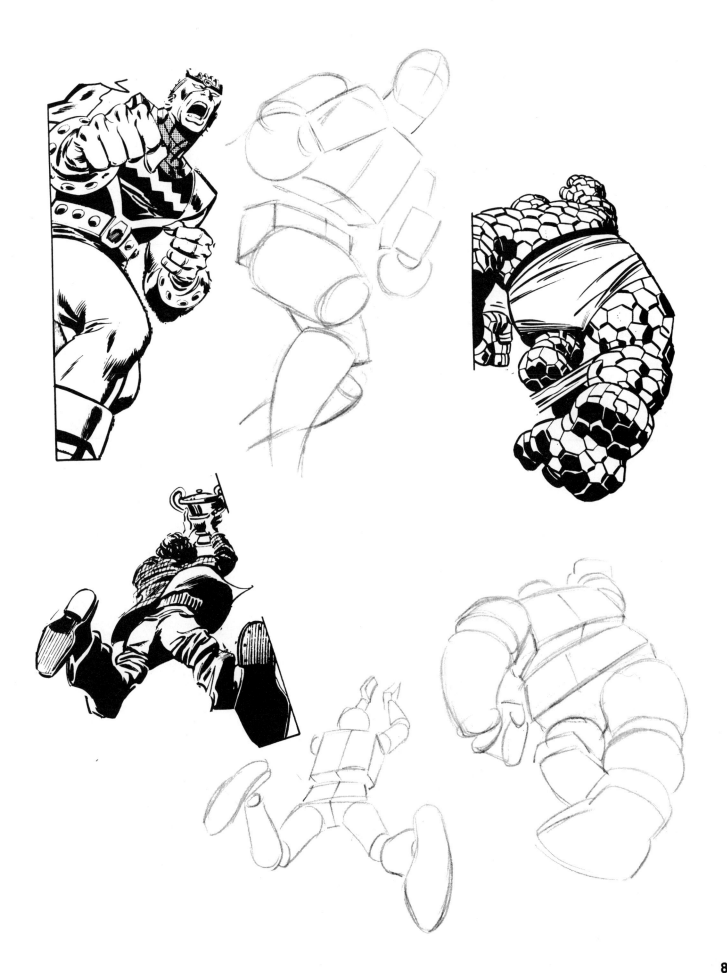

DRAWING THE HUMAN HEAD!

Or even the inhuman head— we're not prejudiced!

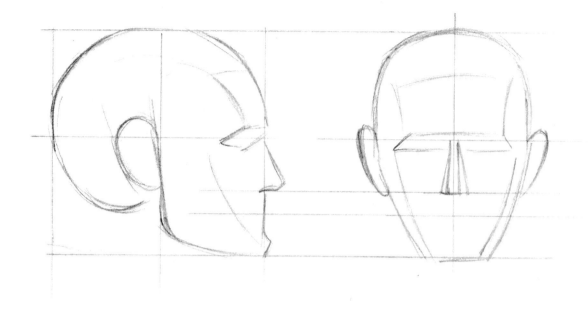

Most everyone can draw faces and heads of some sort—even if the head is just a simple circle with two dots for eyes and a straight line for the mouth. (Sometimes if you omit the nose in such a sketch no one will even miss it!)

However, the time hath come for us to study heads drawn in the Marvel manner. And, since we have to begin somewhere, let's examine the sketches on these pages.

Notice that the head drawn in profile should generally fit into a square (as shown), with the nose and part of the chin protruding.

Also note that the eyes usually come midway in the skull, between the top of the dome and the bottom of the chin.

If you divide the skull into four even quarters, from top to bottom, the nose will usually be in the second quarter up from the chin—with the ears falling in about the same level.

As you can also see, in the full view the head isn't a perfect oval because the jaw has a slope which makes the bottom of the skull considerably narrower than the top.

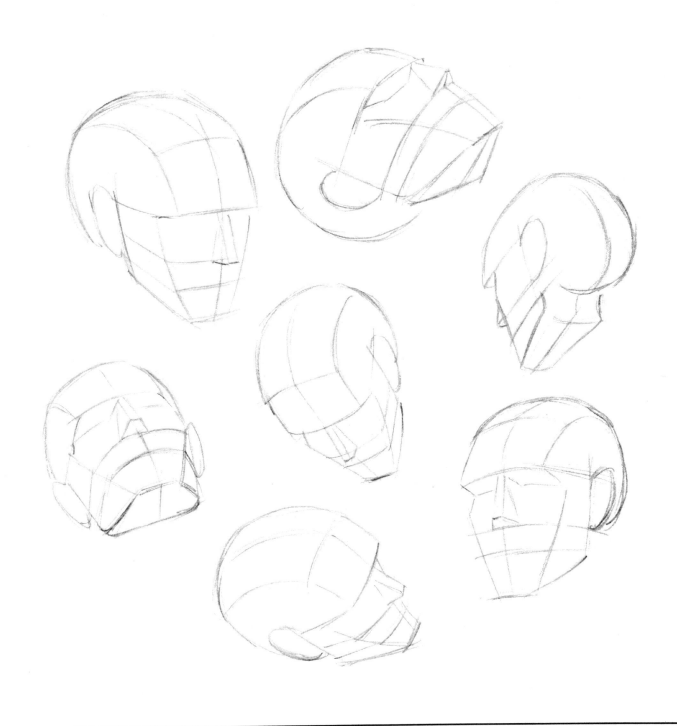

Keep these drawings which depict the skull in different angles, and use them as guides for the exercises that follow. Once you're familiar with this underlying construction you'll be able to tackle practically any type of head imaginable. If you're still not convinced, let's go to the next page . . .

For starters, let's draw a typical hero-type head. Since everything is easier when you've got a few rules to follow, here are some tips you ought to remember:

The head is generally five eyes wide.

There is one eye's distance between the two eyes.

To determine the width of the mouth, draw an equilateral triangle, starting at the top (bridge) of the nose. The triangle goes down, touching the nostrils at the outside of the nose, right? Of course! Well, the width of the mouth is determined by where the two lines cross the mouth line! The same shortcut applies to the chin.

Simply start your triangle underneath the nose, through the lower lip (where it starts to turn up) and, when it touches the bottom of the head—Eureka! That's the width of the chin!

At this stage, keep your faces simple. Notice there are no extra lines in the forehead or around the nose or chin.

Keep the nose somewhat small and make the chin strong and firm.

Give the hair body and thickness. Don't just let it lie flat on the head.

Keep the mouth simple. Notice the curve of the upper lip—and just a small simple line for the lower lip.

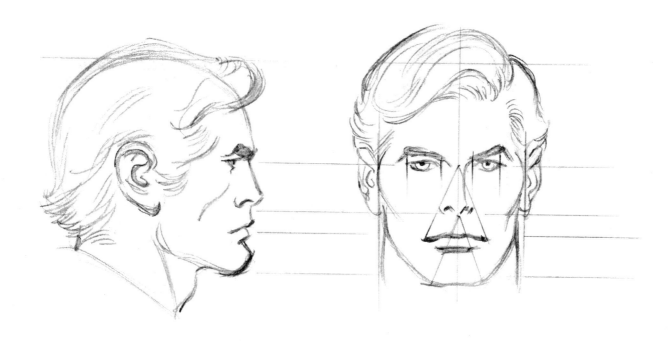

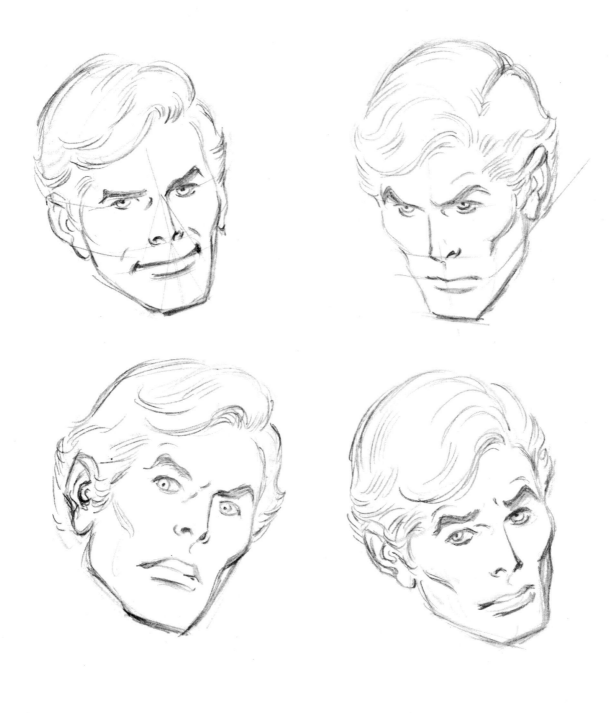

There are, of course, thousands of variations on these little rules. However, remembering these basic principles will make it easier to draw the many different types of faces that await us . . .

As you can see, there are many different types of good-looking males, be they human, amphibian, or whatever. However, the important point to remember is—if you generally follow the rules we've given you, you'll be able to make any character heroic-looking, no matter what his origin or his facial expression.

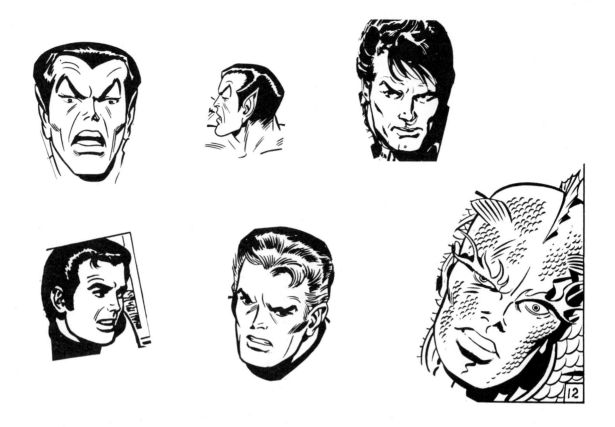

Drawing the good guy is, as you can probably tell, a somewhat formularized task. But drawing the bad guy—ah, that's where the fun is! That's where you can let your imagination run riot and really do your thing!

As you know, your average vile and vicious villain comes in all sizes, shapes, and categories. So, when creating his head, you can use any shape that grabs you—square, round, wide, narrow, pear-shaped, whatever. Of course, you have to be sure that his looks complement his character and personality. The types of villains available to you are virtually limitless. There are the strong ones, the sly ones, the nutty ones, the paranoid ones, the ruthless ones, the grotesque ones, the deceptive ones, the alien ones, and too many others for us to mention since we have to pay for our own typewriter ribbons!

So, if you'll courageously turn the page, we'll give you a selection of sample types, with various different head sizes and head shapes. You pays your money and you takes your choice!

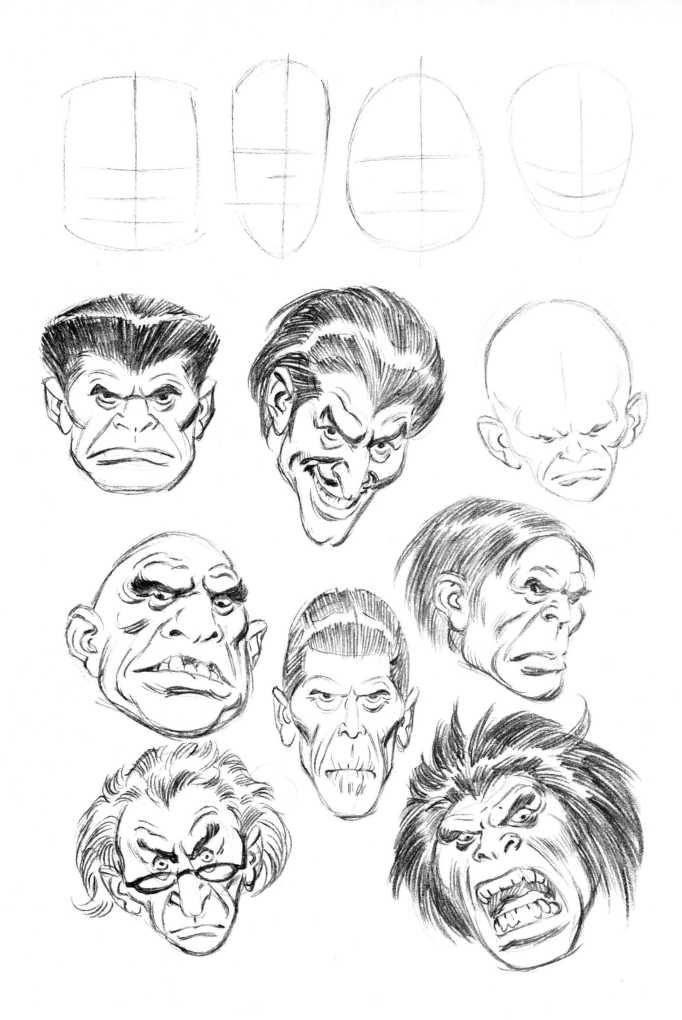

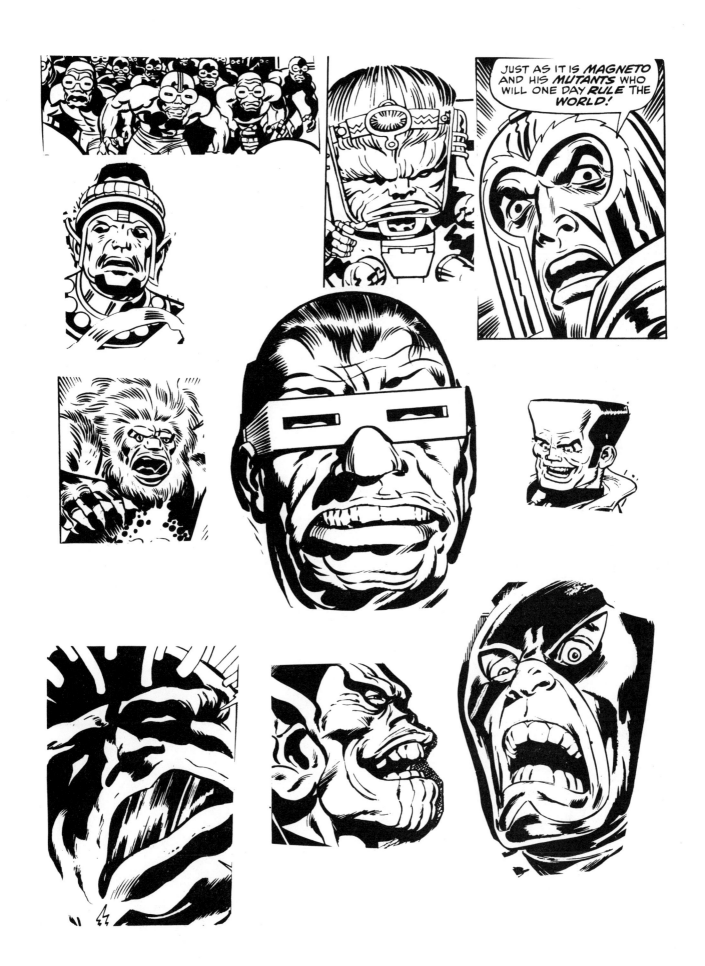

Now we come to almost everybody's favorite part—drawing the face of a pretty girl—and few people are as well-qualified as Big John himself to give you all the info you need. Not only is John one of the all-time greats in the field of superhero strips, but he also is almost without peer when it comes to portraying beautiful females. And, if you need any further proof, read on...

NOTE: We're going to devote quite a bit of space to this section, because the semblance of a beautiful heroine is usually more difficult to produce than a drawing of a hero.

As usual, let's start with five basic steps—the profile first:

Draw the head within an imaginary square, locating the eye line halfway down the face.

Place eye and nose. Notice how the nose tilts out and up from the skull—and is rather short. Using a soft curved line, place the cheek from the ear to the front of the skull, halfway between bottom of nose and bottom of chin.

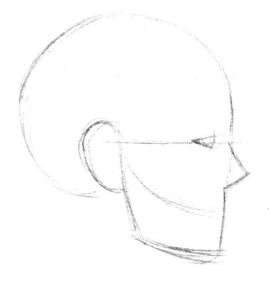

Place the mouth well forward from the skull. Note that the lower lip is fuller than the upper lip, while the upper lip juts out farther forward. See the angle line John drew to show the extension of lips in relation to nose and chin?

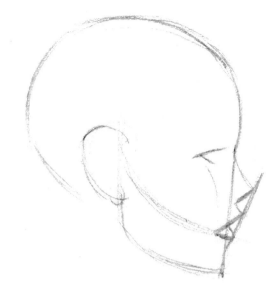

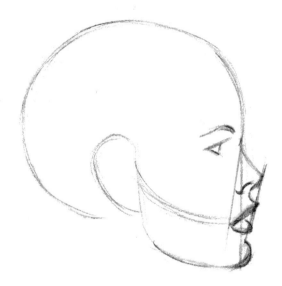

Place the eyebrow, but not too low—and employ a graceful curve. Bring chin forward and find proper positioning of nostril by drawing a straight line from mouth to eye line.

Notice that the forehead is always rounded and never flat. Keep the eyelashes a solid mass—don't try to draw each little lash. And, as ever, keep the hair full and fluffy, not flat on the damsel's dome.

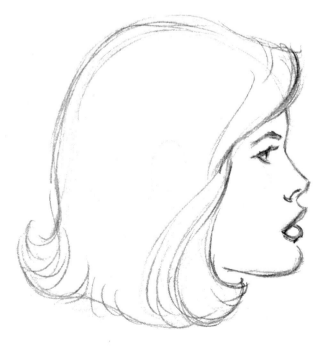

Tell you what. We'll operate on the honor system. John and I will take your word for the fact that you've been faithfully practicing drawing the female profile. We'll assume that you've got it down pat now and are ready to tackle the front-view drawing. See how we trust you?

This time, just so you don't take things too much for granted, we'll hit you with a total of six steps. But don't worry about it . . . they're each adorable!

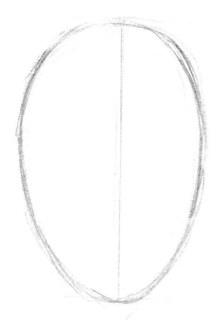

Draw a well-proportioned egg shape. (See? Told you not to worry!)

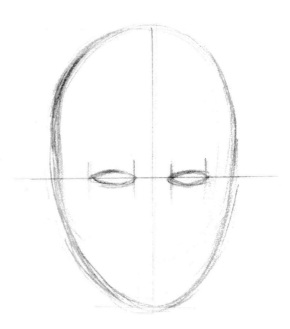

Draw the usual eye line, midway on the skull, remember? A good rule of thumb for you—the head is five eyes wide.

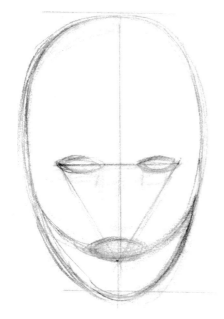

Draw an equilateral triangle (all the sides being exactly the same length, natch!) from the outside of the eyes to the center line of the face. Place your cheek lines and indicate the area for the mouth.

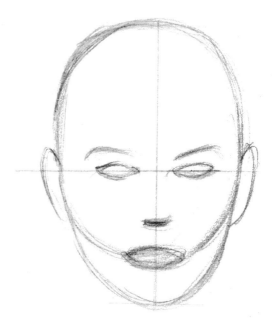

About one-third of the way up from the top of the lip to the eye line indicate the nose. Add graceful eyebrows well above the eyes, and sketch in the ears—one at each side of the head, preferably.

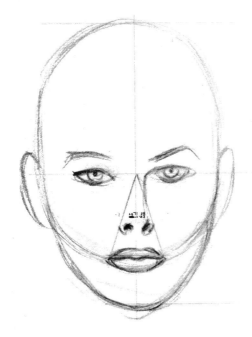

Here's where the real drawing begins. No shortcut for this. You've got to really draw the gal's nose. In the beginning, copy it as best you can from the one Johnny has shown here for you. Always make it a little narrower than the width of one eye, and make sure that it tilts upward. Find the width of the mouth by drawing lines from the top of the nose past the nostrils. The upper and lower lip are positioned by continuing the cheek line through the mouth area.

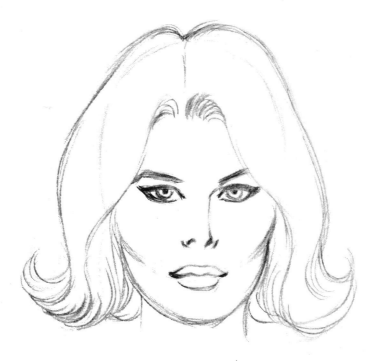

All that remains is to add a head of hair and erase your guidelines. Notice again that the eyelashes are a solid mass, and the eyes are slightly higher at the outside than the inside corners.

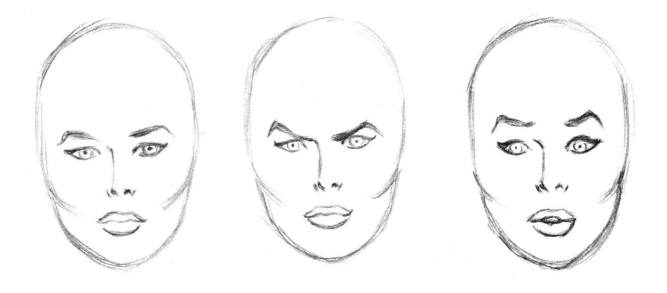

Naturally, being able to draw a head is only part of it. The big thing is to be able to animate the head, to put interesting expressions on the face. So, here we go again.

The faces on these pages were all constructed exactly like the one you've just been studying. Notice how John is able to change the expression as often as he likes simply by making slight alterations in the mouth, the eyes, and the eyebrows. Each expression is obvious. Each expression is different. And each expression can be mastered by you if you'll merely study them carefully and follow these few simple tips:

Keep your female faces simple. Use no extra expression lines on the forehead, or around the mouth or nose.

We repeat, you don't need a lot of lines to show expression, or to change an expression. Keep it clean and open.

Study your own face in the mirror. Practice making different expressions yourself and see what happens to your face when you do. Most artists are their own best models—and the only equipment you need is a mirror.

Virtually the same rules apply to male faces as to female faces (regarding expressions). So study this section carefully, and apply the same formulae to the various male characters you may wish to draw.

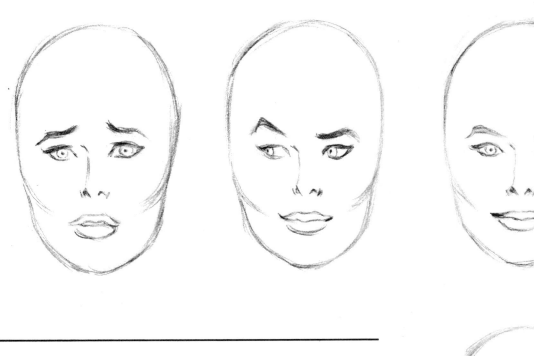

Never forget—once you learn the basic rules, it's fun to change them and come up with your own versions. But you must know the rules perfectly before you can begin editing or revising them.

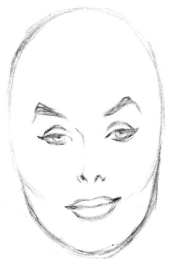

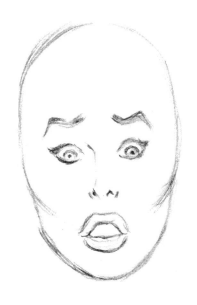

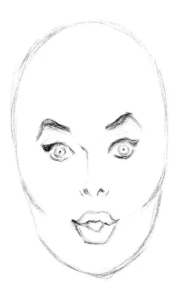

But how about a little variety? Suppose we want to draw a more sophisticated type, or an older woman? Well, that's why we told you to learn the rules first, and then have fun editing them. Here's what we mean . . .

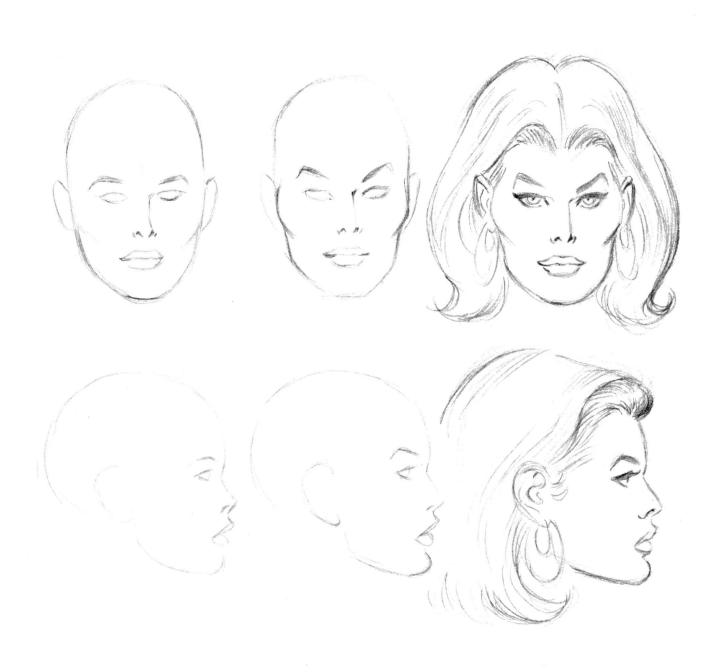

Let's say a story calls for a sophisticated villainess type. Okay, we make the jawline a bit more angular, and then give the eyebrows more of an arch. Also, let's raise the outside corners of the eyes and straighten the nose a bit. See the difference? Still a great-looking female. Still abiding by all the rules we gave you. But, with just the slightest little changes, we've made her a somewhat different type. On the second line we did the same thing to the gal in profile, to show you how she'd look if you were standing to the side of her.

By the way, those two swingy earrings which John lightly sketched help to give the impression of sophistication, also. Naturally, jewelry, clothes, hairdos, and everything else about a woman (or a man) help to create the proper look and mood.

Now, for a somewhat older woman, simply round out the jawline a bit, add a very slight double-chin effect, and with just one curved line under each eye, see how you give a feeling of puffiness (hence, additional age). And, as you can see, her earrings are smaller and more conventional, also suggesting maturity.

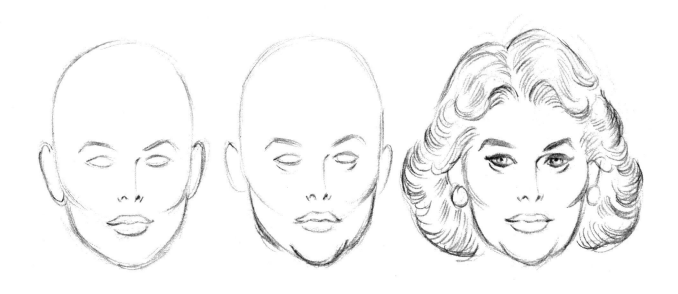

Just to make sure we haven't missed anything,
let's give these important points to remember
a final once-over . . . and let's see what they'd
look like if they happened to be done wrong.

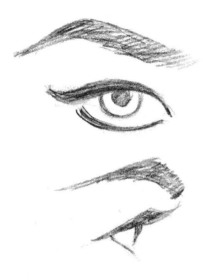

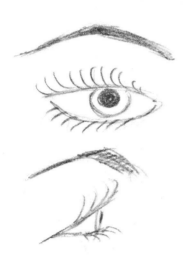

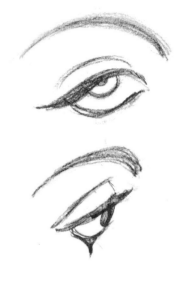

DO draw eyelashes as a mass.
DO tilt the eye upward on
outside.

DON'T try to draw individual
eyelashes. DON'T draw eye too
long and narrow.

DON'T let eyes droop.
DON'T draw eyebrows as a
simple curve.

DO draw nose tilted
upward; DO draw small
nostrils.

DON'T draw nose tilted up
too much. DON'T draw
large nostrils.

DON'T draw bumps on
nose. (It's always one
simple smooth line.)

DON'T let tip of nose dip.

DO learn to draw a mouth with a pleasing shape.

DON'T try to draw bow lips.

DON'T draw angular lips.

DO always place upper lip farther forward than lower one.

DON'T put upper lip *too* far forward, or make it too thin. DON'T make chin too weak.

DON'T make lips too thick. DON'T let lower lip jut too far forward. DON'T make chin too prominent.

On page 106 we present a series of beautiful-girl heads in different positions, to allow you to see how the beauty remains no matter what the angle. Notice how the nose is always tilted upward, regardless of the head's position.

On page 107 we've included females' heads drawn by different artists, to enable you to familiarize yourself with different styles and techniques.

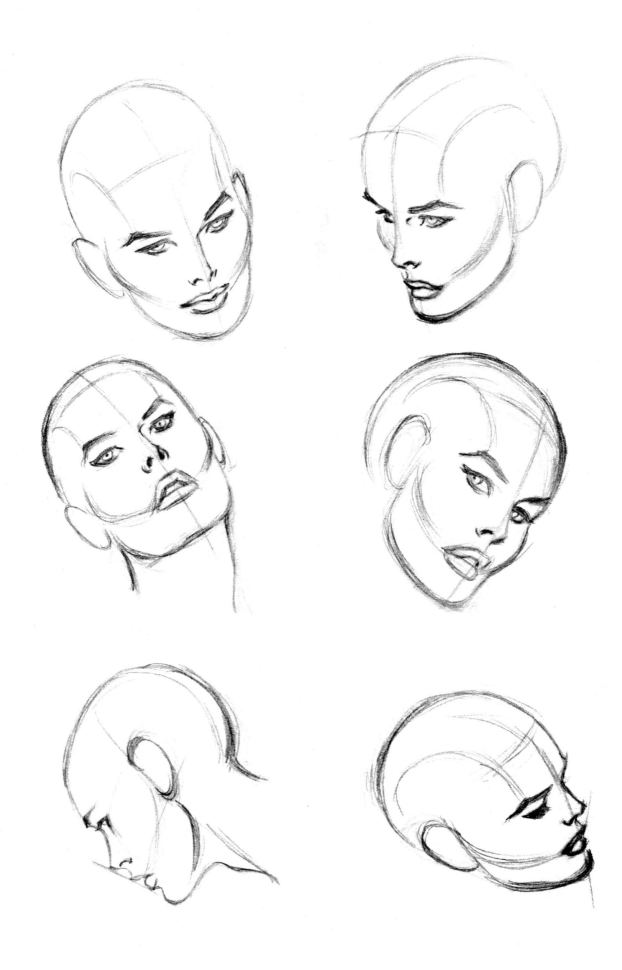

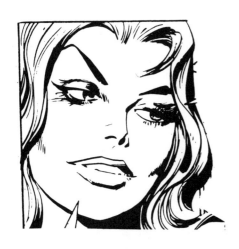

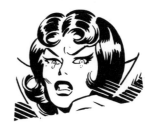

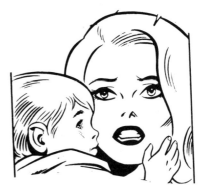
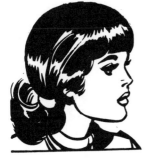

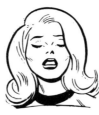
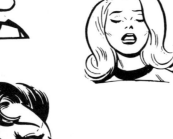

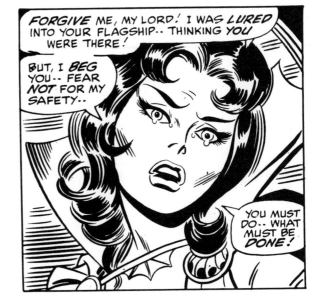

FORGIVE ME, MY LORD! I WAS LURED INTO YOUR FLAGSHIP.. THINKING YOU WERE THERE!

BUT, I BEG YOU-- FEAR NOT FOR MY SAFETY..

YOU MUST DO.. WHAT MUST BE DONE!

COMPOSITION!

Putting the picture together!

● Call it composition, call it layout, call it design—it all adds up to one vitally important point: you've got to put your picture together so that it's pleasing to the eye and it gets its message across clearly and interestingly. The one crucial rule you should never forget is—the simpler the design, the easier it will be for the reader to understand and enjoy it. Make your designs exciting, startling, powerful—but keep them simple.

● Let's consider the facing page. Next to three typical Marvel panels we've used shaded diagrams to indicate the simple, direct flow of the design.

● In each example, notice how the most important elements of each panel fall within the shaded areas. Though these areas seem to be abstract formations, they create unified pictures. The important elements are grouped together rather than scattered. These shaded areas, these prime shapes, are actually sensed by the artist as he draws. The shape is never drawn first, with the elements then squeezed inside of it. Rather, the picture is originally sketched out with the shaded areas taking form in the artist's mind. Sometimes, after a picture is drawn, too many important elements fall outside the basic shaded areas. In such instances, the artist changes his drawing until everything falls within a pleasant, unified mass.

● Once you train your eye to find such patterns, the most complicated picture will lend itself to similar analysis as soon as you look at it. As a matter of fact, let's turn the page and study some additional examples, bearing in mind that no two shapes are apt to be alike . . .

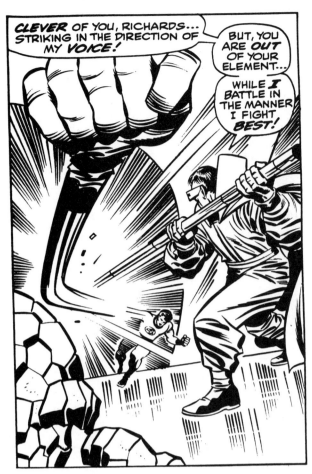

CLEVER OF YOU, RICHARDS... STRIKING IN THE DIRECTION OF MY VOICE!

BUT, YOU ARE OUT OF YOUR ELEMENT...

WHILE I BATTLE IN THE MANNER I FIGHT BEST!

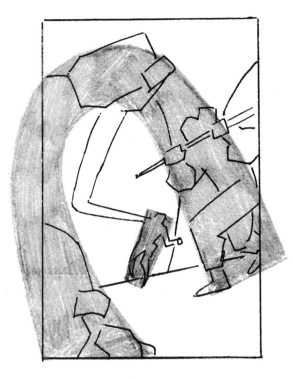

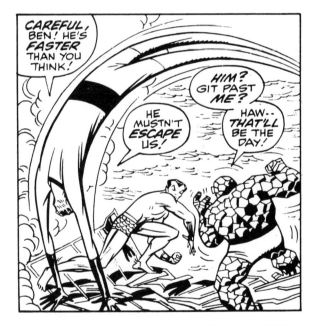

CAREFUL, BEN! HE'S FASTER THAN YOU THINK!

HE MUSTN'T ESCAPE US!

HIM? GIT PAST ME?

HAW-- THAT'LL BE THE DAY!

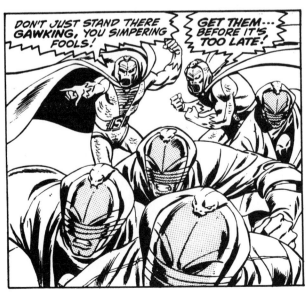

DON'T JUST STAND THERE GAWKING, YOU SIMPERING FOOLS!

GET THEM... BEFORE IT'S TOO LATE!

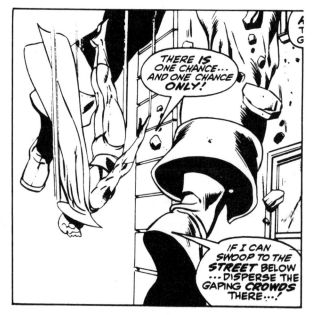

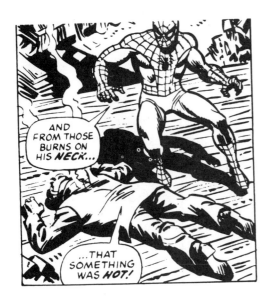

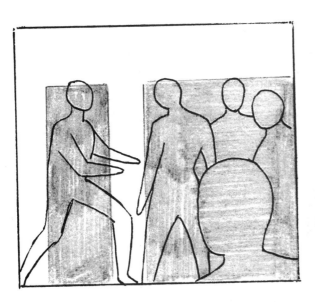

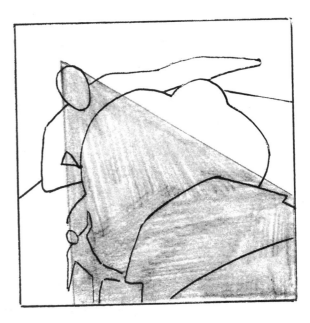

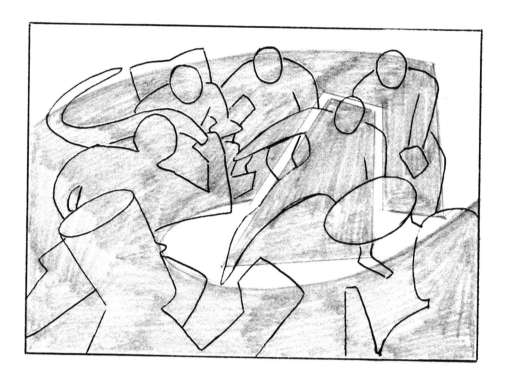

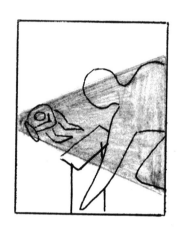

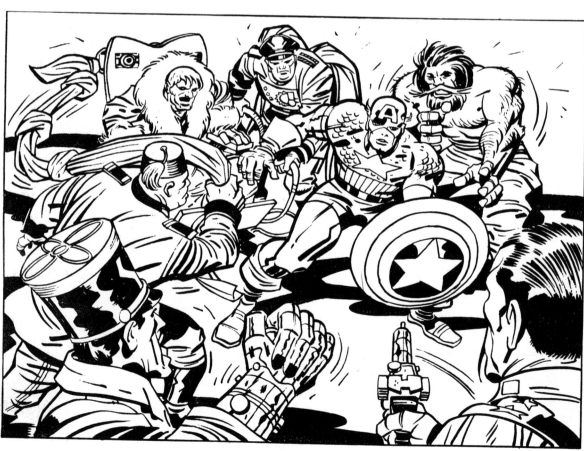

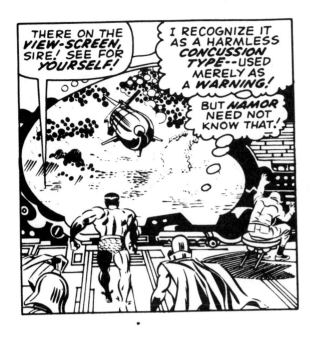

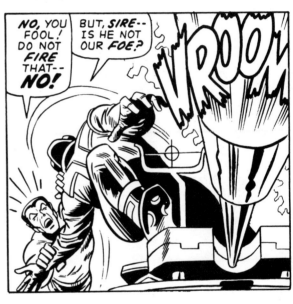

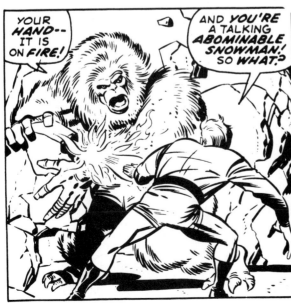

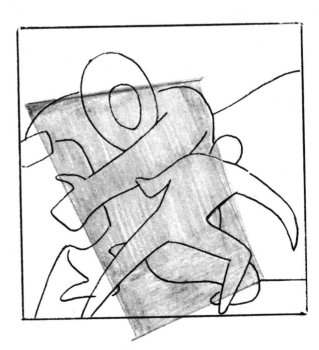

Another vitally important element of design is the so-called "camera angle." Obviously you, as the artist, can draw a scene from whatever angle you desire. You can look at a scene head-on; you can tilt the "camera" (the viewer's eye) upward, or down, or sideways, or any way you wish, just as a movie director can arrange his camera shots to suit his own taste.

As you can imagine, some camera angles are more dramatic, more interesting than others. It's your job to find the angle that will make the most of the picture you want to present, and then to illustrate it for your reader.

Here are three examples of different camera angles depicting three different scenes. Let's study them together for a moment.

Dr. Strange is entering a room. It's a flat, simple, obvious camera angle. Nothing really dramatic or unusual about it.

Same situation, but by changing the camera angle see how the scene has a sense of urgency, of impending drama.

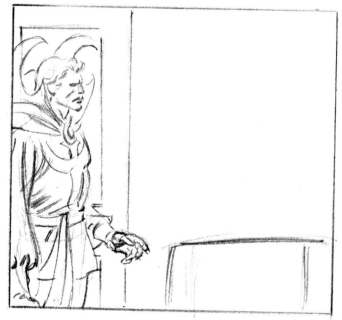
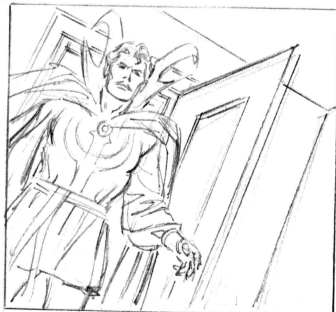

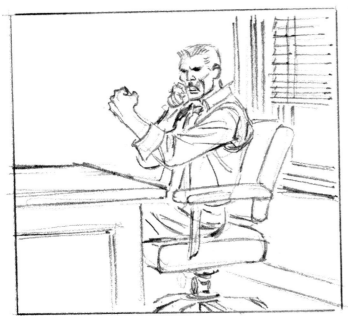

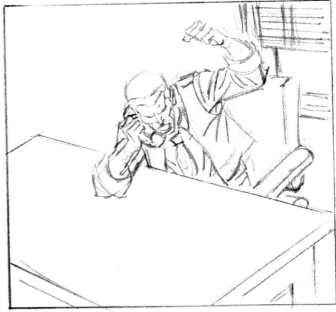

J. Jonah Jameson yelling at Peter Parker on the phone. Okay, but kind of blah.

Different camera angle. Now he really seems to be letting poor Petey have it!

Dr. Doom being his usual rotten self. It tells the story—nothing more.

New camera angle, new Dr. Doom— more menacing, more compelling, better layout!

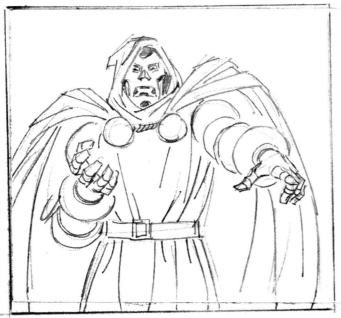

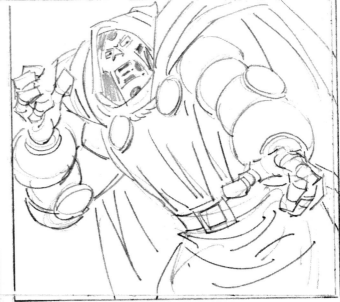

● Let's play a game. Let's take a typical Marvel Comics situation—something that might happen in an AVENGERS story—and draw it in two different ways. The first set of drawings will be fair, the way any comicbook company might do it. The second set of drawings will be done in the mighty Marvel style. The fun will come as we compare the two versions and study the differences.

● On the facing page we present our *first* version—the way any average comicbook might present such a story. Let's take a good look and see what's happening . . .

● As you can see, the page begins with some sort of nutty monster breaking into Avengers headquarters. Panel 2 shows the reaction of three of our heroes. Panel 3 shows Cap, Iron Man, and The Vision rushing to do battle with the intruder. Panel 4 has ol' Shell-head swinging at the big bad behemoth. In panel 5 the monster has grabbed and lifted Iron Man, about to do him irreparable bodily harm. And finally, panel 6 shows Cap and The Vision pondering their next move. Got the picture? Good!

● Now then, the set of drawings obviously tells the story well enough. We can see what's happening, and the characters are certainly recognizable. But they're lacking in heroism, in raw drama, in sheer excitement. Most of the layouts are too vertical (too straght-up-and-down). The figures of the heroes are somewhat stiff and lacking in power and dynamism. Too many of the panels have all the main elements placed too neatly in the center.

● Well, we could go on and on. But it'll be easier just to turn the page and see how it's done the Marvel way!

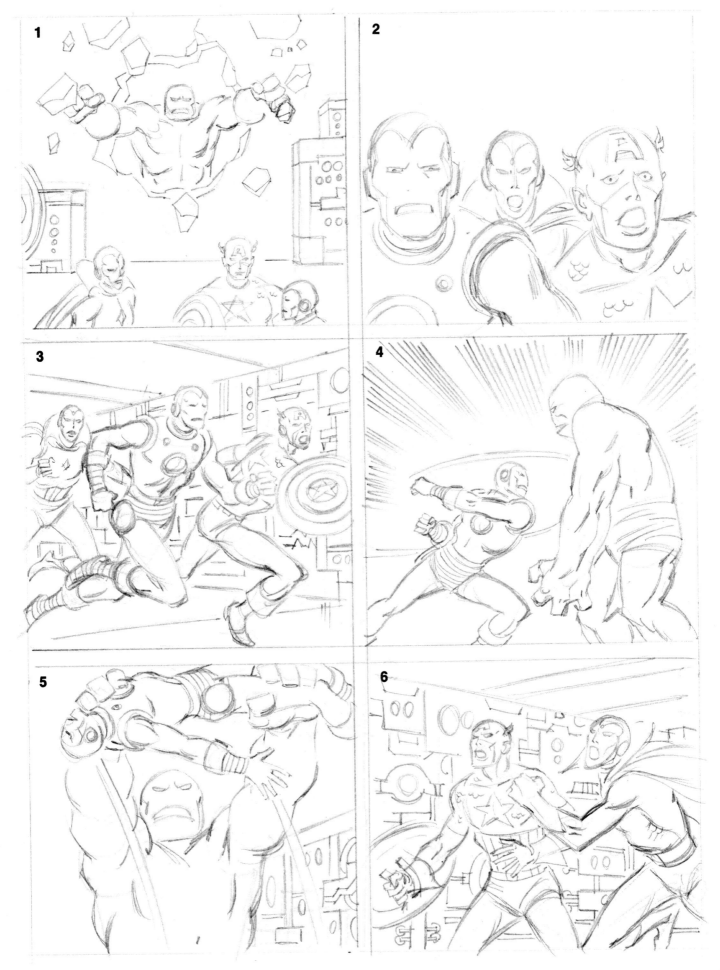

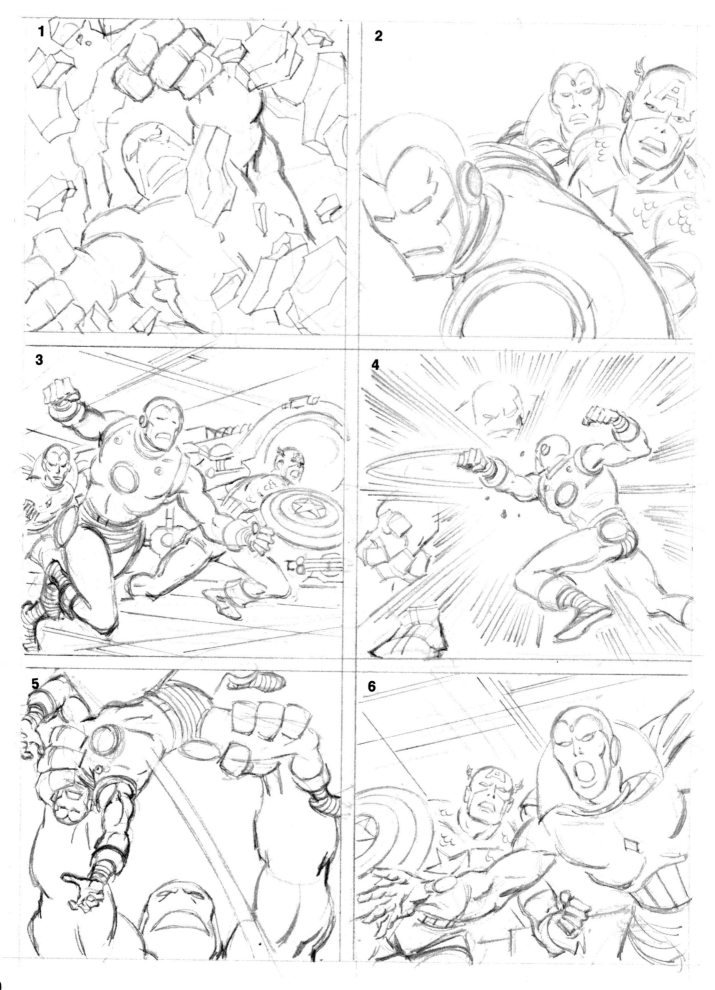

● Now this is more like it! Look at panel 1—look at this close-up of the monster breaking in. He *looks* like a monster—he looks dangerous, menacing, super-strong and deadly. And we don't see our three heroes standing around in a corner of the panel like three simpletons. In panel 2, even though the action hasn't yet started, we get a feeling of movement, due to the placement of the figures, with Iron Man in front, followed by the others. It's not a simple, looking-straight-on panel. How about that panel 3! See the action, the drama, the feeling of power generated by our heroes! Just compare it with the one on the preceding page and we won't have to say another word. Panel 4, of course, shows Iron Man hitting our mirthful little monster the way a hero's supposed to—as if he means it! It doesn't look like he's a ballet dancer, as in the other version! As for panel 5, Iron Man is now far less stiff; he really looks like he's struggling to break free— and he still looks powerful enough to have a chance of doing it! Finally, in panel 6 the two Avengers are much more graceful looking, and the tilt of their bodies gives a feeling of far more urgency and excitement.

● You might also have noticed that the elements in each of these panels are not as evenly centered as on the preceding page. This gives a feeling of more movement and better design. And you must be aware that there is more variety insofar as the size of the figures is concerned. A panel is much more impressive when the figures are drawn different sizes. It gets dull for a reader to see characters who are pretty much the same size throughout the page.

● Now, we'll give you another two pages of the same type of thing. Without any comments from us, see if you can tell why the second version is infinitely better than the first. If you need a few clues, you'll notice more interesting and varied perspective shots, more variety in the size of the figures, and less emphasis on putting everything directly in the center of the panels. See how many other points of improvement you can find in the second version. It'll be good practice for you in training your eye to tell a fair layout from a really good one.

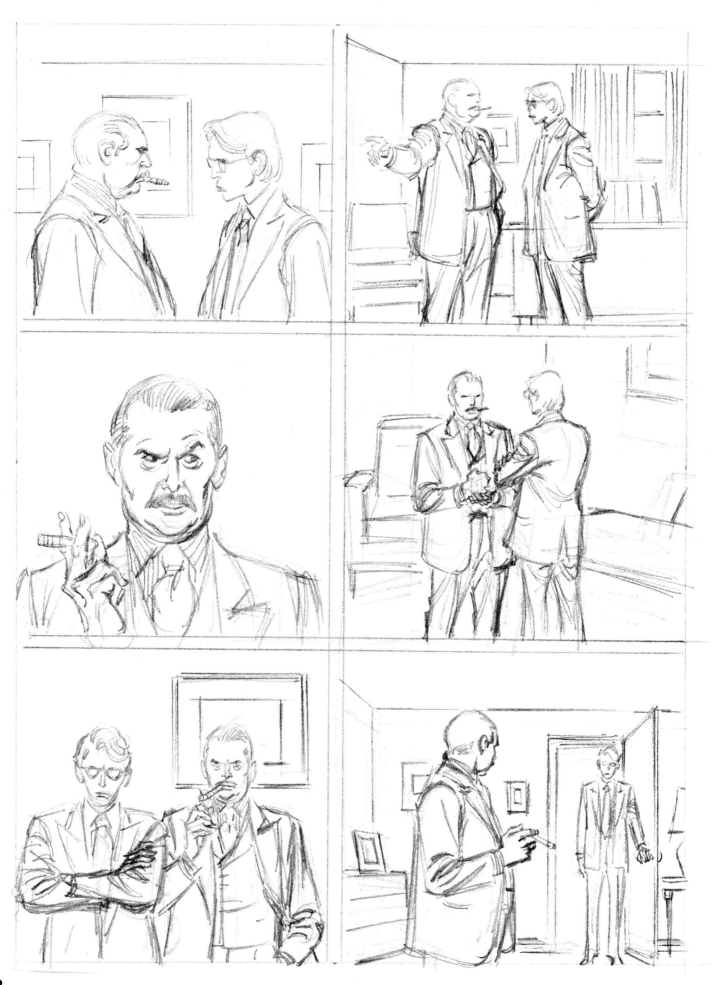

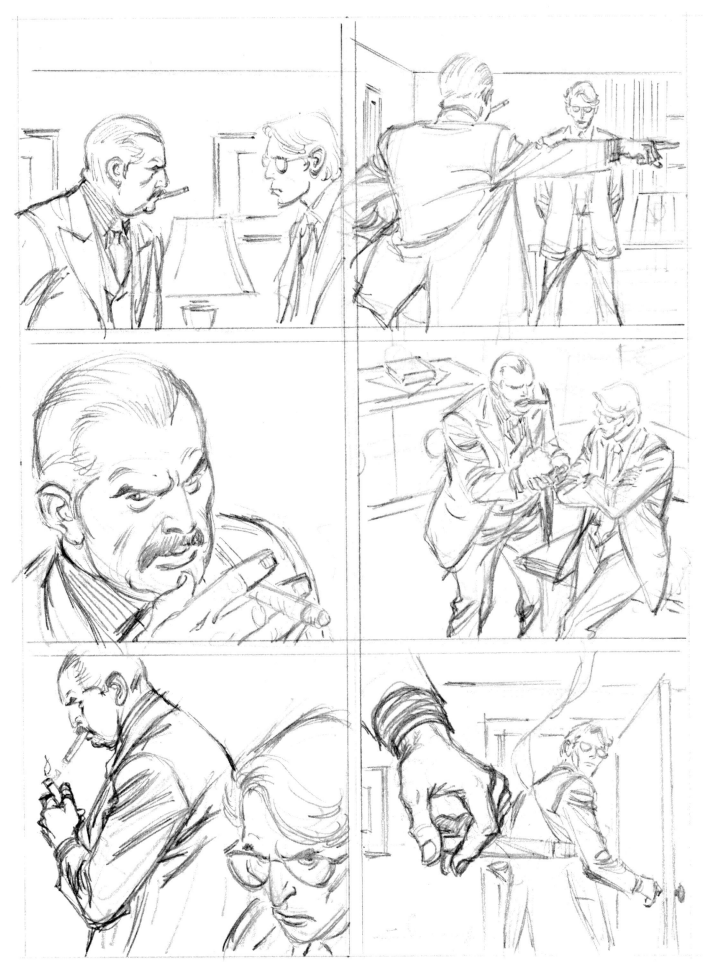

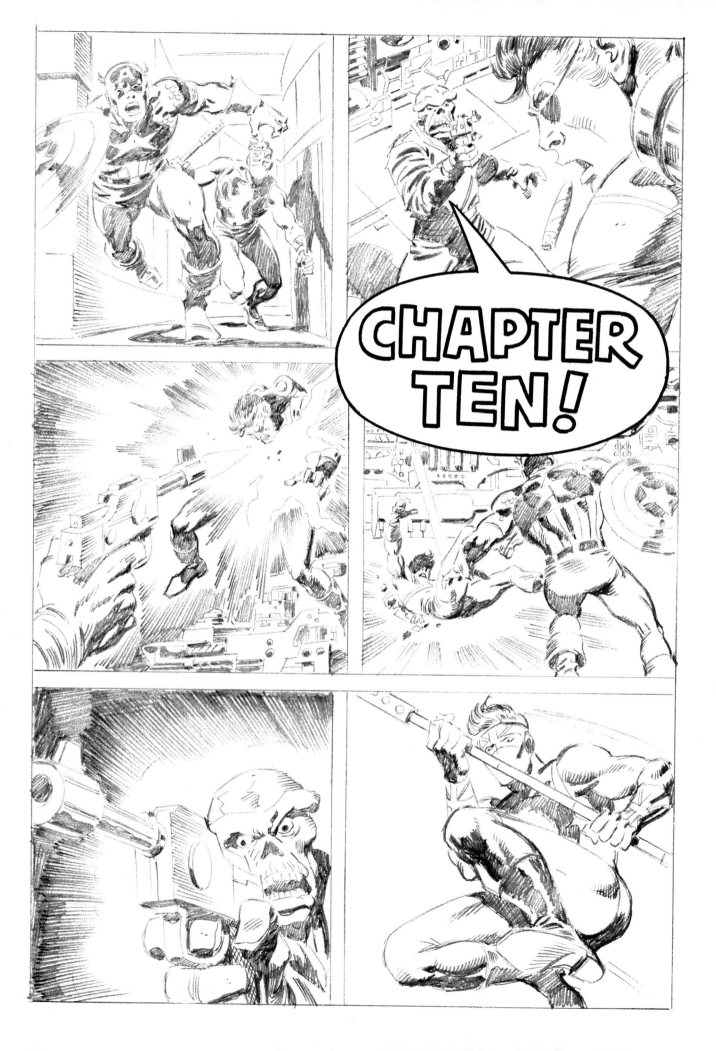

DRAW YOUR OWN COMICBOOK PAGE!

If we can do it— so can you!

As far as we know, this is the first time this technique has ever been offered to anyone outside the halcyon halls of Marvel! On the pages that follow, we're going to show you, step by step, exactly how a page might be penciled for a comicbook.

Actually, the page you're about to study was originally done for a strip called CAPTAIN BRITAIN, published by Marvel Comics for distribution and sale in Great Britain. The artist was given a plot description rather than a complete script containing dialogue. Therefore, we won't concern ourselves with captions or dialogue balloons, but merely with drawing the panels according to the plot.

Now, here's what we have to draw. In panel 1, Captain America, followed by Captain Britain, races down a corridor on a rescue mission. Panel 2 depicts the villainous Red Skull aiming a gun at his enemy, Nick Fury, who hovers above him, held aloft by twin jet-packs, which he wears on his back. Fury reacts in surprise as he hears his name called by Captain America. Panel 3 is a shot of the Skull firing point-blank at poor ol' Fury! In panel 4, Fury drops to the floor as Cap rushes to help him. Panel 5 shows the Skull about to zap the star-spangled Avenger. And we wrap it up with panel 6, in which Captain Britain, holding his unique armored staff, charges to the rescue.

Although you've already seen the finished product on the chapter head on page 124, the important thing for you now is to see just how the whole thing was put together. But before you breathlessly turn the page, remember to always lay out the entire page before you finish any individual drawing. Also, always draw the entire figure in each panel, even if it won't all show in the final artwork.

This is the first draft, done purely for layout and action—just to position the characters. Basically, it consists of a set of stick figures, giving the artist an idea of what his page may look like and how the action will flow from panel to panel.

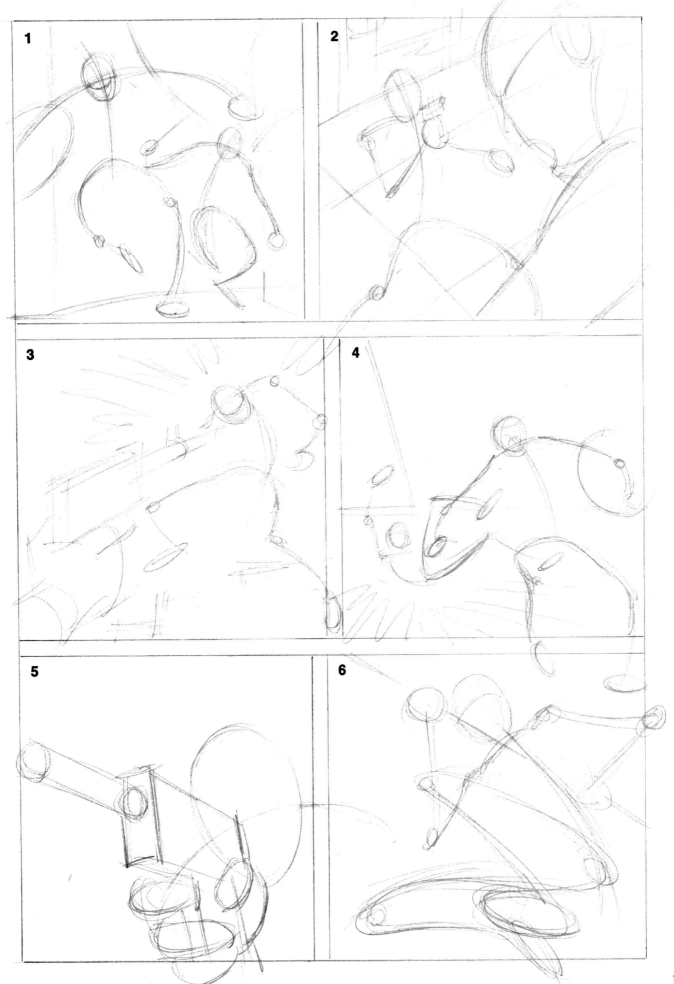

This is where the artist starts building his figures, using the spheres, cubes, and cylinders we studied earlier. Notice how he will draw through a figure wherever necessary. And see how the original stick-figure line now becomes his action center line.

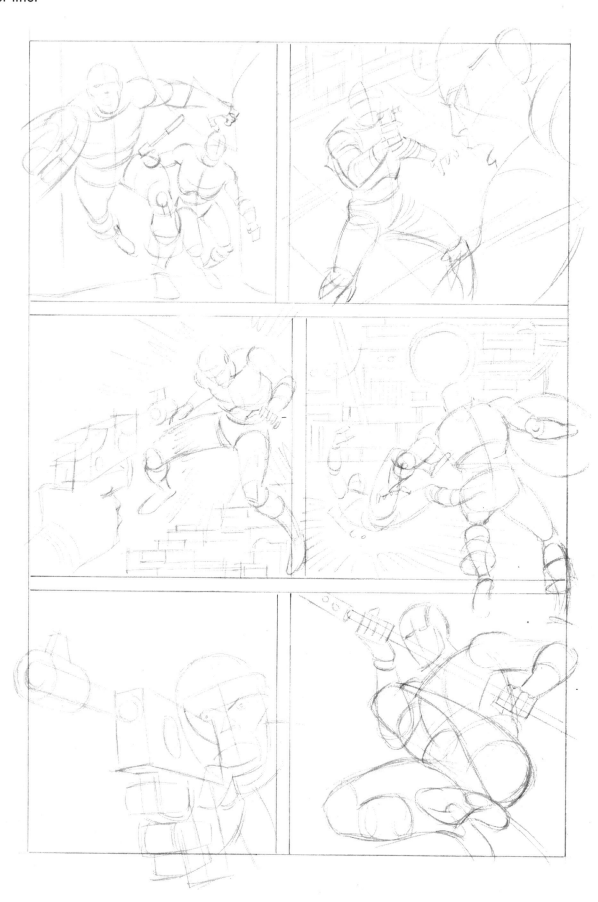

This is it—the "fleshing-out" process, which we discussed in Chapter Five. As you can see, from spheres, cubes, and cylinders it's not a very big step to the completed figure—at least not once you've learned how to draw the face, the body, and all the other things we've been so brilliantly explaining!

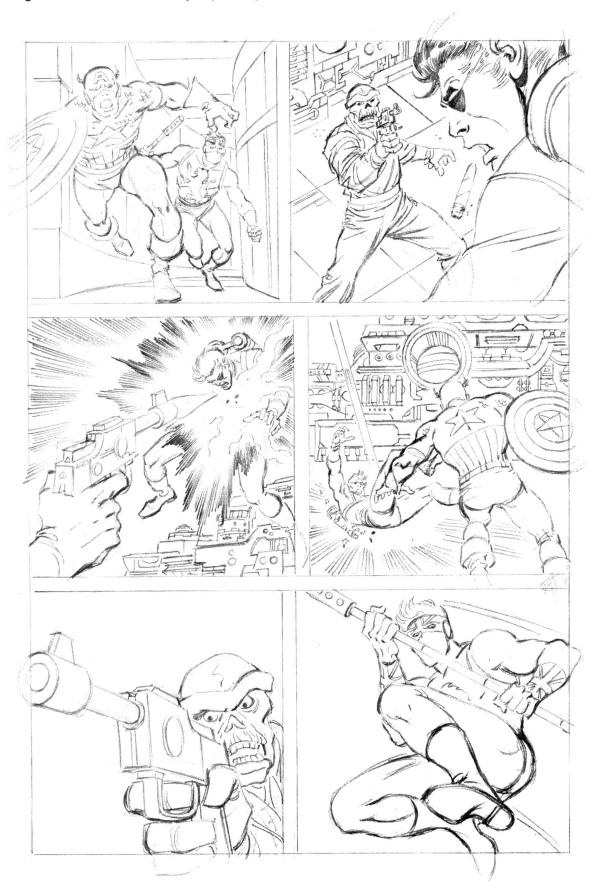

Okay! Since you did such a great job on that one, let's try another!

This time let's see you draw your own page—in the same stages as you've just observed—before you look at the pages that follow. Then you can compare your own handiwork with ours—and there's always the chance that yours will be better!

Here's the plot:

Spider-Man, out to get revenge against the Silver Surfer, finds him on a rooftop. The Surfer warns our friendly neighborhood web-head to stay back. In order to show Spidey that he means business, ol' SS mildly zings him with a teensy cosmic bolt. Spidey, having been knocked off his feet, decides to fight back. Spider-Man quickly zips some webbing at the Surfer, catching it around his ankles. Finally, the Surfer, wrapped in Spidey's webbing, loses his balance and topples off the rooftop.

This scenario was written so that each sentence describes a separate panel, for a total of six panels to the page.

That's it. You're on your own. Sketch out a page as best you can, following the scenario, and then compare it with our version. Remember now, do the stick figures first; then the spheres, cubes, and cylinders; and finally the fleshing out. You can compare each process with ours as you go. Enjoy!

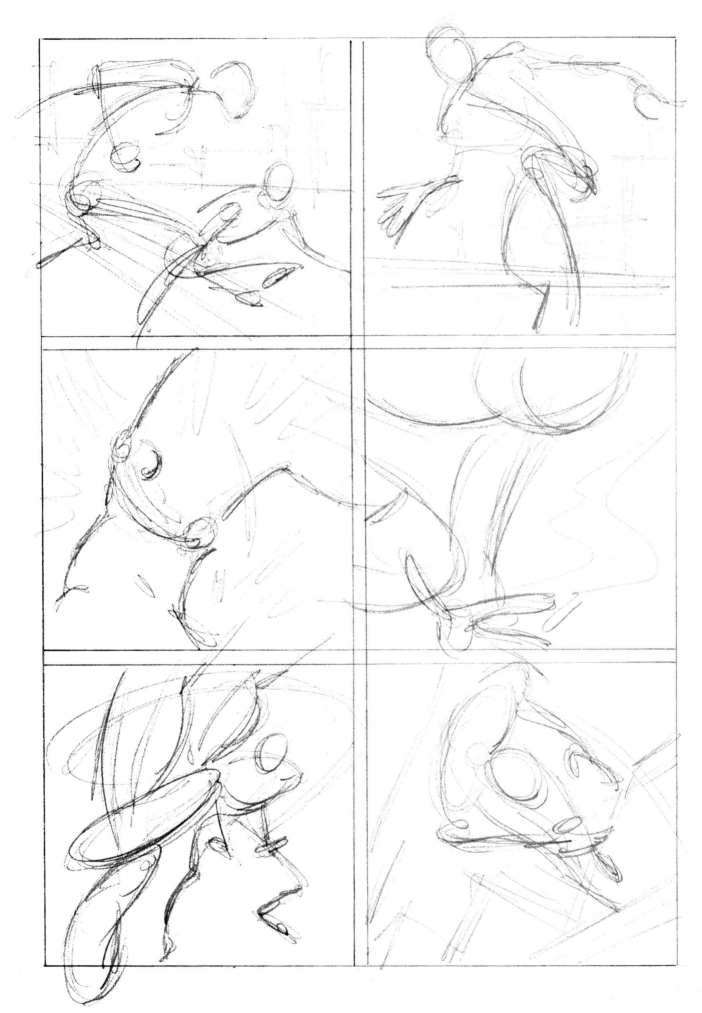

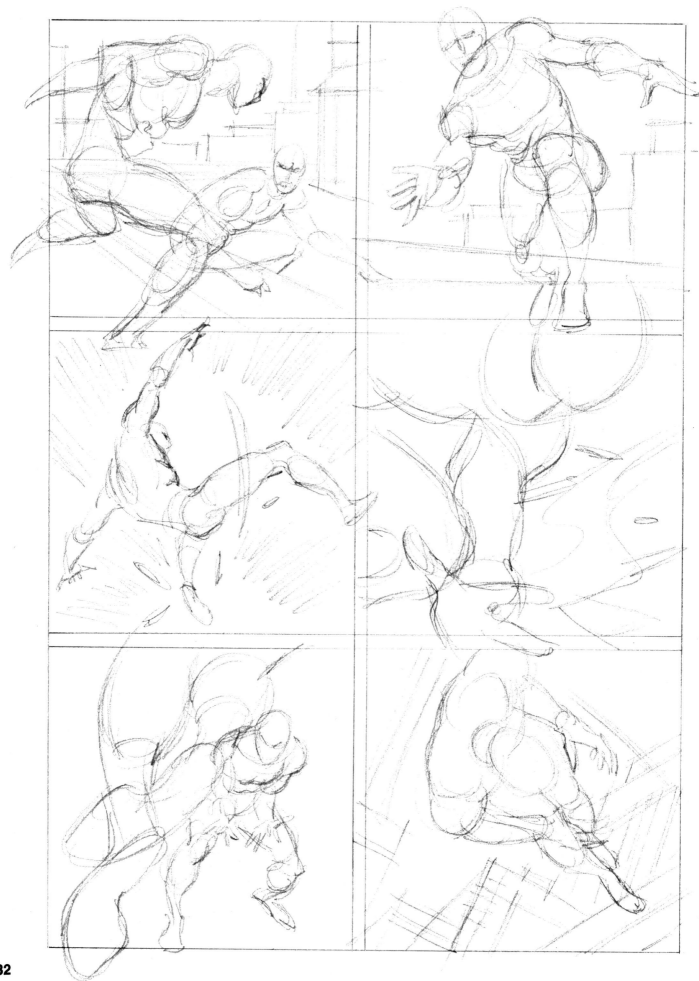

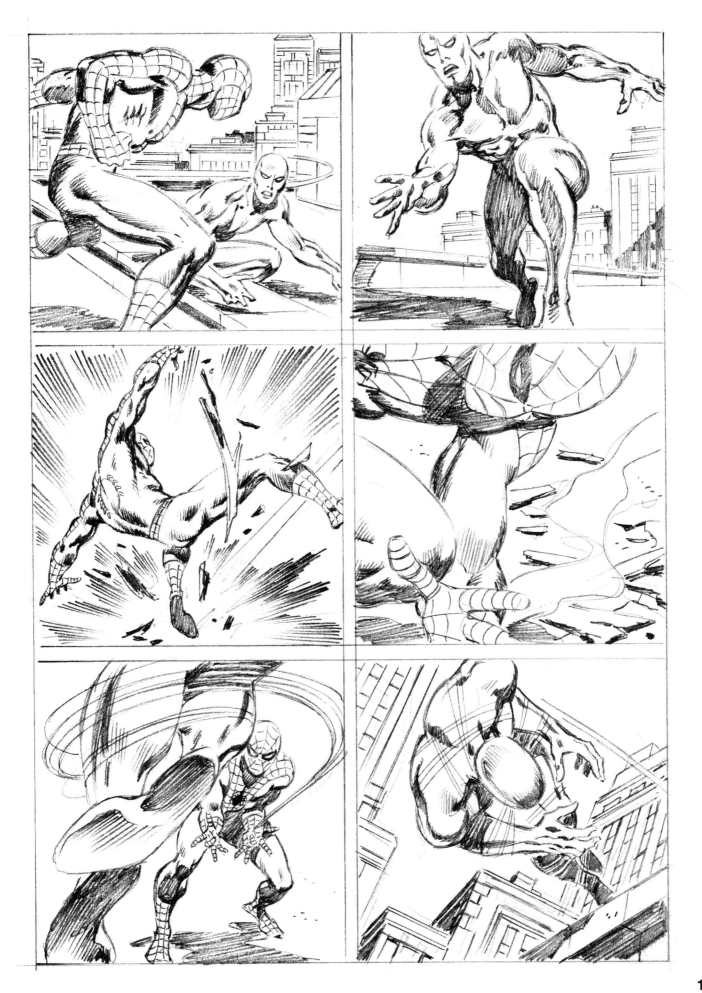

● How did you do? Better than you expected, eh? If so, congratulations. If not, don't worry about it. Try some more, making up the situations yourself. That's the way most of the pros in the comicbook field got their start, by creating and drawing their own stories and strips, and then using them as samples to show the editor at a comicbook publishing company.

● But now, before we go on to the next chapter, let's just take a minute to review the "design" of the panels you've just been studying. Remember that the design is as important as the basic drawing—in fact, the design is part of the basic drawing. Note the design patterns in the panels on the facing page. Try to train yourself to spot such patterns in every panel you look at, and especially in every panel you intend to draw.

● Okay, summary time's over. On to the next goodie we have in store for you . . .

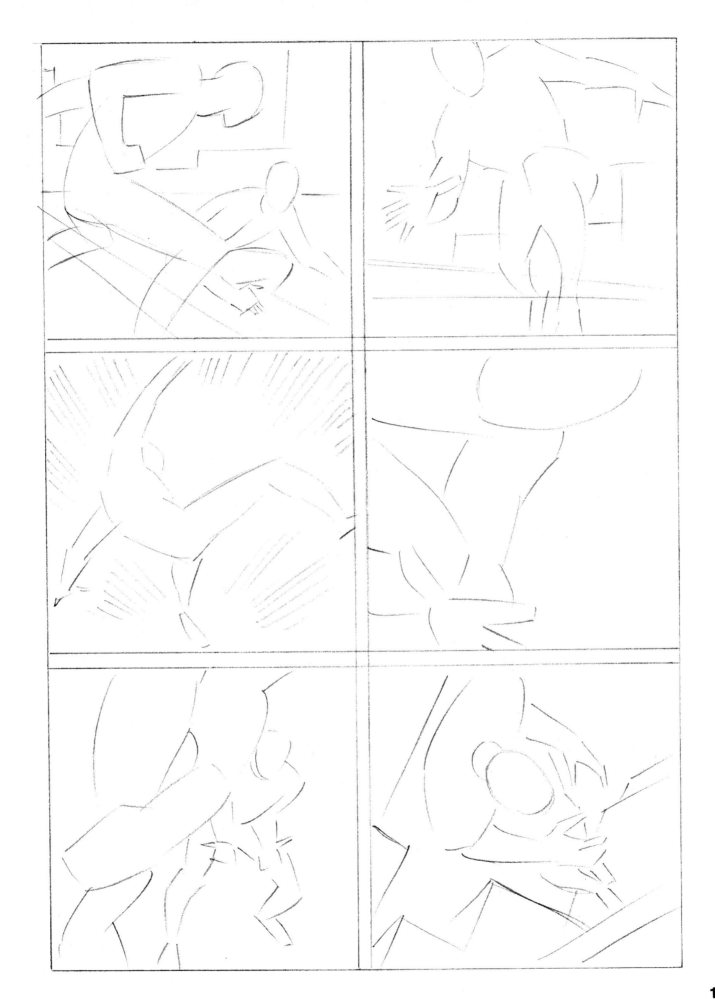

THE COMICBOOK COVER!

Without which you cannot tell a book by!

As you can imagine, the cover is probably the single most important page in any comicbook. If it catches your eye and intrigues you, there's a chance you may buy the magazine. If it doesn't cause you to pick it up, it means one lost sale.

Consequently, more thought and more work go into the cover than any other page. Usually the editor will create an idea for a cover with the artist who is about to do the illustration. Then, if time allows, the artist may do a number of simple layouts which he'll discuss with the editor until one final version is agreed upon. On the facing page we show what we mean . . .

Since we thought you'd be curious about the comments and criticisms of these layouts, here's a sample for you to mull over:

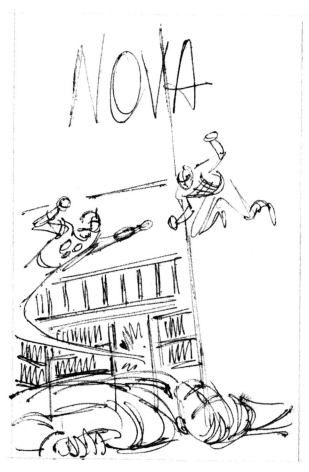

1

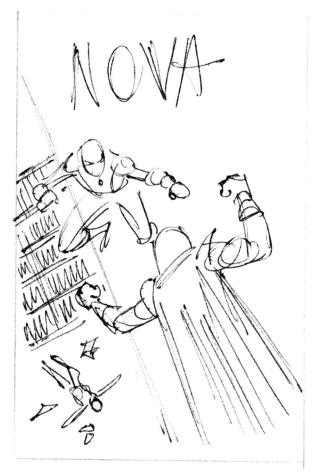

2

1 The figures of Nova and Spider-Man are too small. They don't have enough punch.

2 Not bad, but Nova is the star of the magazine and the editor didn't like to have nothing showing but Nova's back.

3 Too much wasted space on right side of cover. Also, even though Spider-Man is just a guest star in this issue, we'd like to see more of him.

4 This is the one that was selected. We get a good view of both Nova and Spidey, and they're much larger than in layout 1. Also, the perspective is more interesting because the reader's eye level is up high with the two heroes.

One point to remember—these are all matters of opinion. Actually, cover sketch 2 is really quite interesting, even if we don't see more of Nova, and 3 has a lot of impact because the figures are even larger than in 4. Unlike mathematics, no opinion is ever 100% correct. We just try to show you how we feel about these things, to help you formulate your own decisions and opinions.

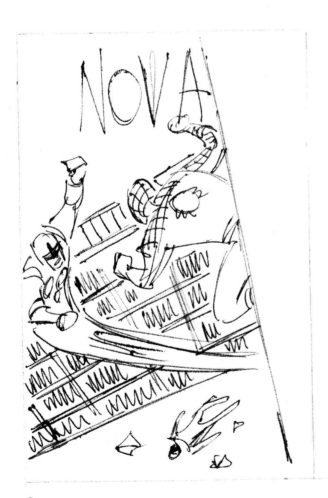

3

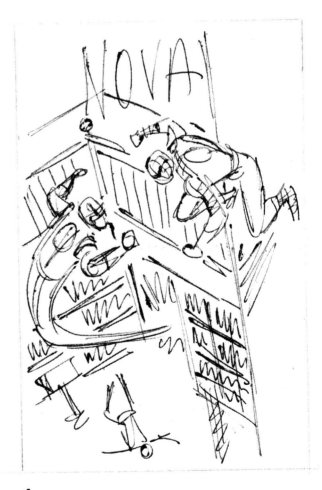

4

Because of the importance of the cover, and because it serves as a full-color advertisement for the magazine itself, all the elements of the illustration must be very carefully put together. Here are some of the things which the artist must always remember:

Always leave enough room at the top of the illustration for the logo (title of the magazine).

Nothing important must be drawn at the outside edge of the bottom or the right side of the cover, because some of that paper is trimmed off at the printing plant. This area, approximately a half inch in width, is referred to as the "bleed."

There must be a number of "dead areas" on the cover—areas which, although exciting-looking to the reader, are unimportant enough to be covered over by dialogue balloons, captions, and/or blurbs if the editor so desires.

Since the color on a cover is vitally important, the artist mustn't use too many heavy black areas in his illustration. The expression employed in the Bullpen is: "Leave the drawing open for color."

The drawing must be provocative enough to make the reader want to get the magazine and read the story, but it mustn't give the ending away, or tip the reader off to any surprises.

Well, that's enough for you to cope with at present. Now, once again, let's trace the progress of our drawing from the initial rough stage to the completed pencil version. The final inked cover can be seen, of course, on page 136, where it was used to introduce this unforgettable chapter.

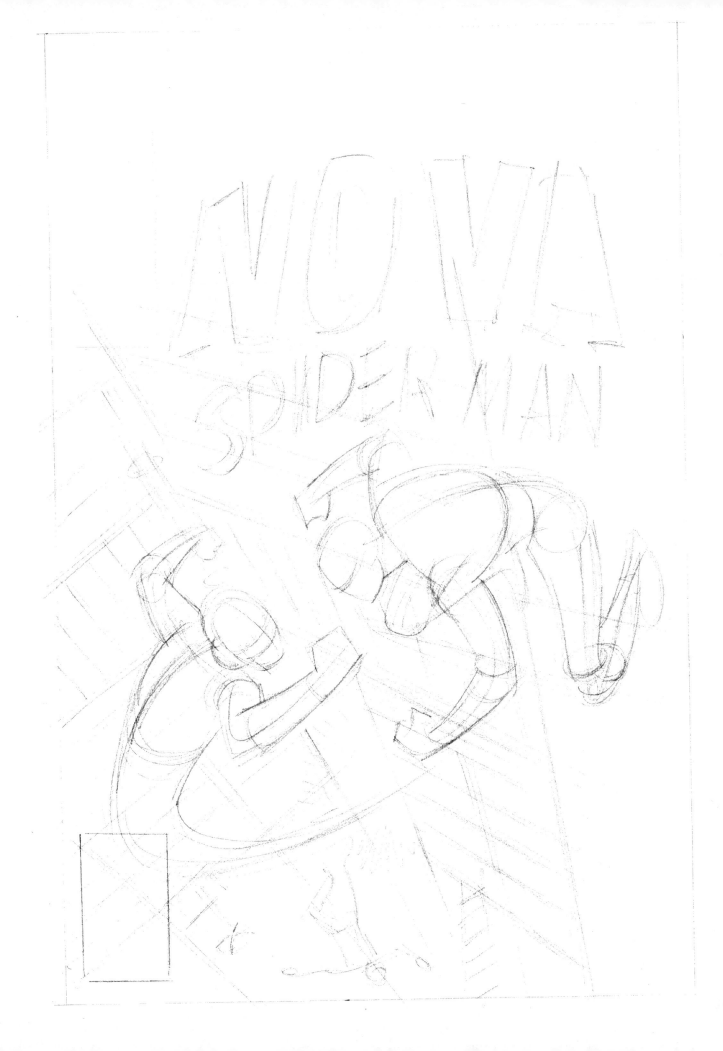

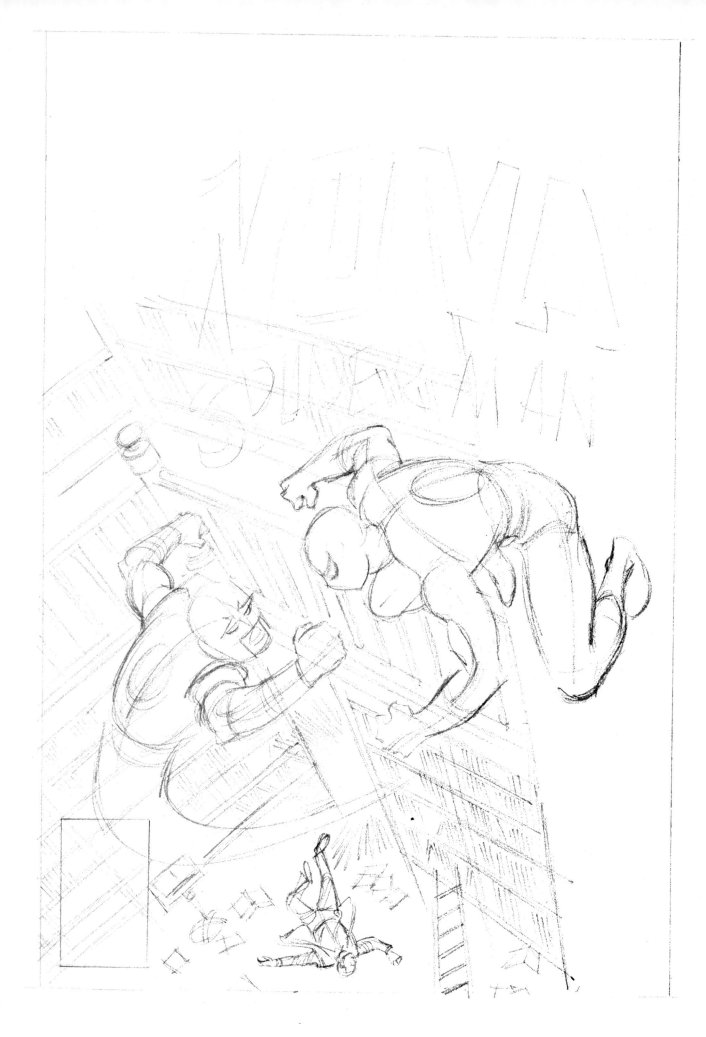

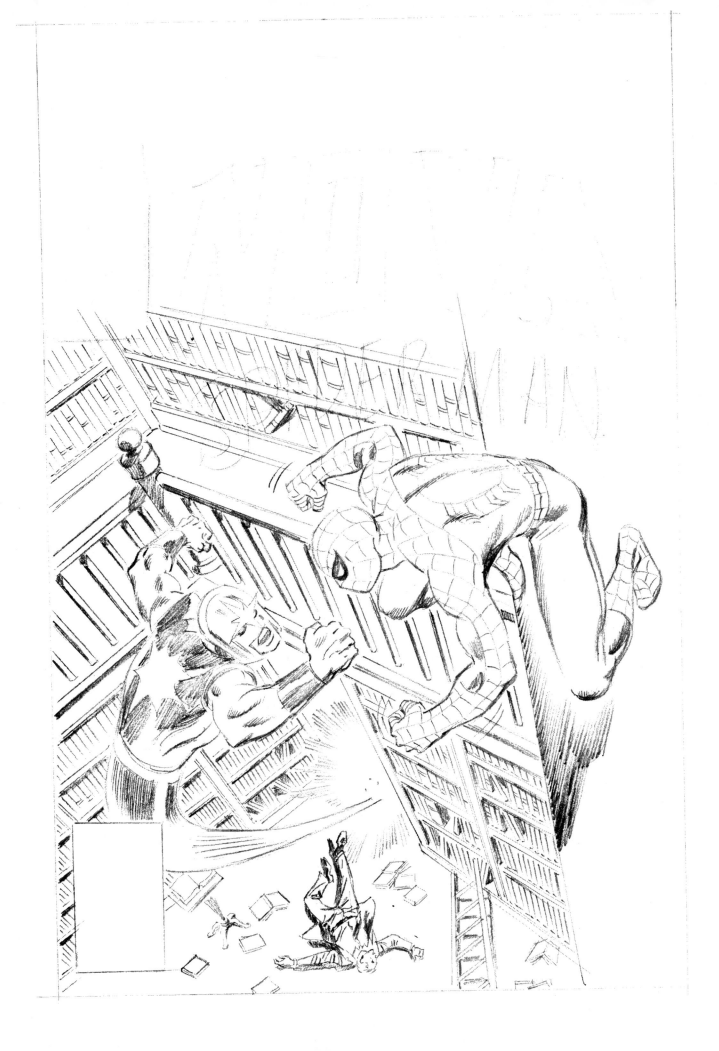

THE ART OF INKING!

No matter how beautifully a page may be drawn in pencil, it cannot be printed in a comicbook unless black india ink is applied to the original pencil drawing. That means someone has to trace over the initial penciled artwork with either a paintbrush or drawing pen, transforming each illustration into a carefully "inked" final product.

However, always remember that an inker is not merely a person who traces a penciled drawing. The inker has to be an artist himself. (Or herself. No chauvinists we!) A gifted inker can make mediocre penciling look great; while a mediocre inker can make great penciling look dull!

Inking is vitally important. The more you know about it, the better. And here's where we begin . . .

Inking can tend to be tiresome, and it requires relentless concentration. Therefore, you should make sure your posture is correct. Whatever you do, don't slouch over your drawing board. Sit up straight—slouching will make you weary and listless.

TIP: The ink in your pen points and brushes will become hard and stiff if you don't keep them clean. Always keep a jar of clear water at hand and soak both brushes and pen points when they're not in use.

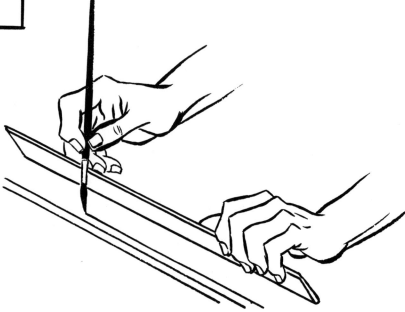

Even though india ink is more permanent than pencil, don't get uptight if you make a mistake. You can always paint over your error with opaque white paint, and—as soon as the paint dries—you can ink right over it.

For ruling lines (which inkers are continually called upon to do) you can use a ruling pen. No need to dip it into the ink, though. You merely load a brush with ink, and then run it over the pen until the pen is filled.

Later on, when you feel more adventurous, you can actually rule lines with your brush. It's far more difficult, but it often pays off because your finished lines will have more character, more interest. They won't be as stiff and totally uniform as lines ruled with a pen. Merely hold a ruler at about a 45-degree angle, and by varying the pressure of your brush, you can make lines of virtually any thickness.

Your best bet is to become equally facile with both pen and brush. The pen is easiest when you're just inking black lines, but you'll need a brush for filling in solid black areas. Of course, you can also use your brush for drawing lines, but it's more difficult than the pen—it requires greater control on your part. The lines must be clean, sharp, and decisive—not ragged or scratchy. Still, we suggest you learn to use a brush—learn to virtually draw with your brush instead of merely tracing the pencil lines. You should feel you're creating them anew with the brush—feel that you're drawing them—otherwise the finished drawing may seem stiff and lifeless.

Notice the patches of design below. They were all done with a Windsor Newton #3 sable hair brush. Patches 1 through 4 are called "feathering." This is when your brush "feathers" a number of roughly parallel lines. Notice how some strokes go from thin to thick—all done with the same brush, by merely varying the pressure you place upon the brush. Patches 5 through 8 were done using the side of the brush. This technique is handy for inking hair on a character's head. In case you're wondering, 12 was done by dragging the point of a razor blade along the edge of a ruler.

Try duplicating these various strokes and, even better, see how many of your own you can create.

And now, let's take a few typical examples of inking and study them. We'll see if we can tell what's good about them—and what needs improving . . .

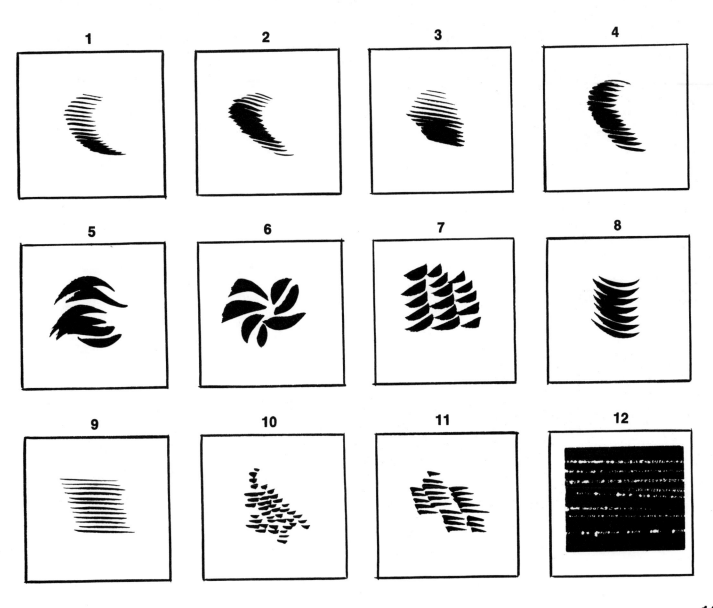

Here's a well-inked panel, shown the size it was originally worked on, and then reduced to the size it would appear in a comicbook, so that you can see how well it reproduces even when scaled down to comicbook panel size. Notice how the lines vary in thickness, and how they're heavier on the underside of the bodies—away from the light—giving solidity to the figures. Note also how clear the picture is, even though there are many figures and a wealth of detail. One of the most important tasks the inker faces is to insure that the drawing will be understandable to the reader, no matter how complicated it may be. One way to achieve this is to use heavy blacks to make the figures stand out from the background, as in this example.

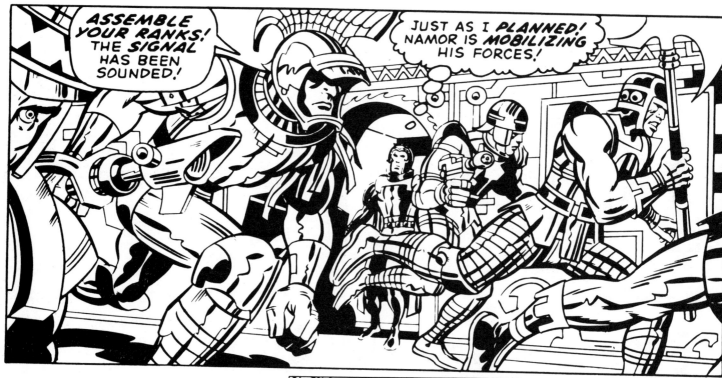

Here we've taken the same panel and overworked it—used too many blacks and too many lines. Notice how complicated it looks in its original size, and how much less clear it is—how much more difficult to understand—after it's been reduced to comicbook panel size. Adding too many details and too much texture in the inking has made the figures blend with the background instead of standing out in sharp relief as the penciler intended. In short, the picture has become much harder to read, less pleasant to look at, and will also be more difficult to color.

Using the same penciled drawing once again, we go to another extreme. This time the inker didn't get nearly enough variety in his lines, or in his black areas. As you can see, his lines are almost all the same weight, with no feeling of "thick and thin." His solid black areas are too skimpy and too spotty; they're scattered all over the panel in no definite pattern, and seemingly for no particular reason. The figures don't stand apart from each other and they all seem to blend in with the background. As you can see, it's just as bad to keep a panel too light as it is to overwork the drawing.

Sometimes a penciler indicates in his penciled drawings where the black areas should go. Other times he leaves it to the inker. However, no matter how the decision is arrived at, the important thing is to know when and where to place your strong black areas, for too little or too much black can weaken or totally destroy a penciled drawing.

While the black masses of course give a drawing solidity, they also help focus important elements in a picture by attracting the eye toward any desired area. Equally important is the use of solid and strong black masses to create dramatic moods within the drawing. Now, let's study some examples to help us clarify these points . . .

Notice how the heavy black areas here are concentrated on just one side of the figure. There are almost no blacks in the light area on the other side. This technique serves to accomplish two things: 1) It gives the figure a feeling of dimension, of roundness. 2) It directs the reader's attention to the character's head by framing the head with massive black areas, directing the reader's eye to the all-important fearful face.

In this panel we have similar lighting, with one bright light source illuminating one side of the body and casting the other side in deep shadow. Even though the figures are drawn quite realistically, note how boldly and simply the heavy black shadows are applied. For the most dramatic effects, keep your inking simple, with just one definite light source in each panel.

Now let's analyze two more typical panels through the use of simplified diagrams. In the top panel, the artist's main purpose was to create a mood of fear and menace. Once again, notice how boldly and simply he applied his black masses. The heavy shadow seems to totally engulf the smaller white figure, which is sharply highlighted for maximum emphasis. In the corresponding panel on the right we've reduced the entire design to its simplest form, so that you can easily discern the crisp contrast between the stark black and white values.

Always remember—the placement of your black areas creates a definite pattern in every picture. This pattern must never be too complicated, or too busy, lest it confuse the reader. Whenever an illustration causes confusion in a reader's mind, it also causes the reader's attention to be diverted, thus breaking the dramatic mood that each preceding panel has attempted to create. In other words, Charlie, keep it simple—and keep it clear!

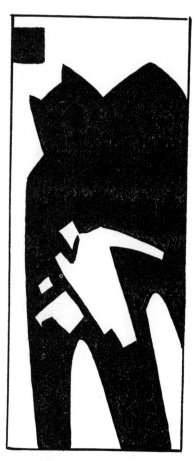

Here we have an extremely complicated scene. Yet, despite the wealth of detail, note how the placement of the black areas creates a pattern which seems to draw the reader's eye smoothly across the picture. Notice also how the three figures in the center have been given just enough black dabs—especially around their heads—to allow them to stand out from the background.

Next time you study a panel in order to analyze the inking technique, train yourself to squint your eye and try to recognize the way the black areas are massed for design, in the same way as we've attempted to show you by use of the two simplified panels on this page.

Here's a different application of blacks. On the previous page we saw the black areas used in a very realistic way; here we have an example of blacks being used decoratively. Notice how the black highlight lines on the ship seem to be aimed directly at the figures, focusing the reader's attention on Reed, Sue, and the baby. Notice also how the blacks in the upper areas of their bodies encircle the three heads, directing your eye right to the cluster of faces.

Next we have what seems to be a complicated arrangement of blacks but is actually a simple, very direct pattern. In this case, the use of blacks directs the reader's eye around the panel in a smooth, harmonious rhythm. See how the black shapes at the right side of the panel are large and bold, while those at the left are far smaller. The purpose of these smaller black areas is to counterbalance the larger black masses at the right. To prove this for yourself, simply cover the smaller, left-hand black areas with a piece of white paper and notice how the panel seems lopsided and off-balance without them.

Never add blacks merely because you've got some extra ink in your pen or brush. Always have a definite reason—either to enhance the design of the panel, or to help clarify a complicated layout. Of equal importance, of course, is the use of black to emphasize a certain mood. And, speaking of mood . . .

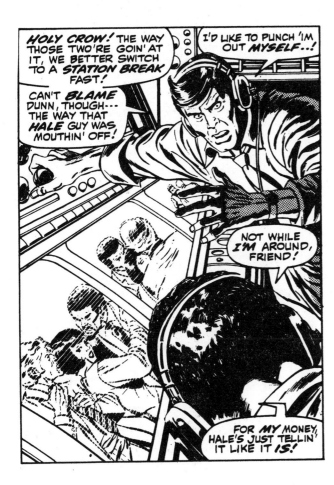

Hey, how lucky can we be! Here's a perfect example of the use of blacks to create a certain mood! By squinting our eyes, or observing the simplified panel on the right, we can instantly see that all the black areas are in crisp, simple vertical or horizontal forms, thereby creating a calm, motionless scene—with the dramatic exception of the large, slanting black masses on the winged gargoyle, which add a sudden feeling of shock, of uneasiness, of impending danger and menace!

The large, vertical black designs within the fence bars are also tremendously important in this illustration, for they serve to unify the entire picture. Without them, the whole design would seem to fall apart.

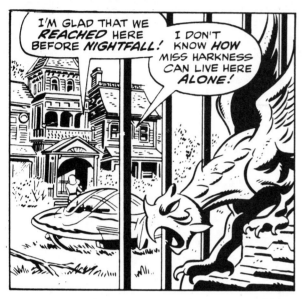 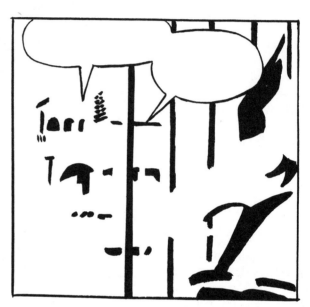

In the panel below we have an entirely different feeling. Here, in order to dramatize the mood of the panel, the black designs seem to be jumping all over the place, creating a scene of chaos and action. But even here, note that the pattern—though seemingly jumpy—is also quite unified and consistent, helping to rivet the reader's eye on the action within the picture. From the standpoint of abstract design, the black areas are arranged to create a pleasing, exciting circular movement.

As you once again squint your eye to study the scene, notice how the two slashes of black across the bottom of the picture, from right to left, add to the action and also act as a unifying force.

 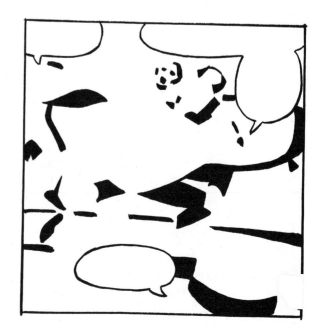

For our final two examples, notice how this first picture is handled with extreme realism. The light is obviously coming from the left, casting everything on the right in deep shadow. See how the heavy black shadow areas emphasize the feeling of a horror story. You know it isn't a humor strip or a romance, just by looking at the design of the panel. Also, observe the way the black areas in the background give a feeling of authenticity and detail without detracting from the two important figures themselves. The panel is heavy, it's lush, it's melodramatic; and yet it's clear and compelling. In a word, it's Marvel!

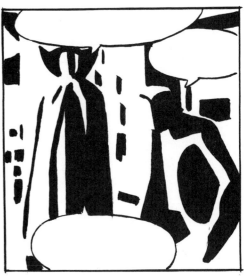

Okay, let's consider the bottom panel. Notice how the large black areas on the building seem to point directly to the most important element of this picture, the leaping figure of Spider-Man above the roof. Of course you've already observed how the black designs in the figures of the police at the lower left serve to counterbalance the large black masses on the building. Another interesting point: the agitated staccato pattern of black and white on the officers seems to emphasize their action and frustration.

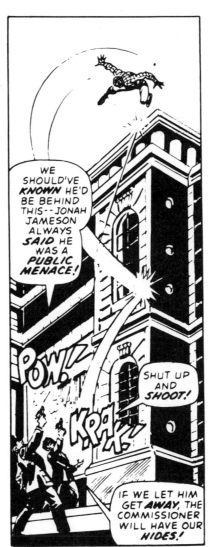

In summation, the penciler draws his panels in pencil, and then they must be finished by the inker. And, as you can see, it is up to the inker to decide where, and how boldly, to apply his black ink. The inker figures very importantly in determining the mood, the design, and the clarity of each panel. Thus, when you study a comicbook's artwork, you must always be conscious of two elements—the basic penciled drawing, and the inked version. Together, they add up to a completed illustration which is proudly presented to Marveldom Assembled!

Well, that wraps it up for now, gang. Naturally, we've only been able to scratch the surface of this fascinating, almost limitless subject. However, we hope that in these all-too-brief pages we've been able to give you a valuable and informative overview of what it takes to draw for the comicbooks. All anyone can really do is point the way—give you a few tips, a few suggestions. The hard work, alas, must be done by you.

And yet, the beautiful thing about being a comicbook artist—even about *striving* to be one—is that you have to love it in order to want to do it. Nobody gets into this field because someone else advised it, or because it seemed like a practical thing to do. No, being a comicbook illustrator is being engaged in a labor of love, and when you really enjoy what you're doing, that's almost reward enough.

At any rate, we've told you all we can—at least for now, in this, the first volume of its type ever published. You've gained some insight into what's required of the comicbook artist, and you've learned the types of things you must master in order to make the grade. The rest is up to you.

One last word before we turn you loose to unleash your talent upon a breathlessly waiting world. To be a great singer, you've got to sing. To be a great pianist, you've got to play piano. And to be a great artist (and Marvel isn't interested in any other kind), you've got to draw! Draw! Draw! Wherever you go, whatever you do, whenever you have a spare minute—draw! Sketch everything you see around you; sketch your friends, your enemies, relatives, strangers, anyone and everyone. Become as facile with a pencil, pen, or brush as you are with a knife and fork. The more you draw, the better you'll be. And we want you to be—the best!

Excelsior!

BIBLIOGRAPHY

Suggested books to study for more detailed instruction
on the various subjects touched upon in this volume.

Anatomy Books

Bridgeman, George, *Bridgeman's Guide to Drawing from Life* (Sterling).
————, *Bridgeman's Life Drawing* (Dover).
Hogarth, Burne, *Drawing the Human Head* (Watson-Guptill).
————, *Dynamic Anatomy* (Watson-Guptill).
Vanderpoel, John, *The Human Figure* (Dover).

Books on Composition

Fabri, Ralph, *Artist's Guide to Composition* (Watson-Guptill).
Graham, Donald W., *Composing Pictures* (Van Nostrand Reinhold).
Watson, Ernest, *Composition in Landscape and Still Life* (Watson-Guptill).

Perspective

Cole, Rex, *Perspective for Artists* (Dover).

Animal Drawing

Hamm, Jack, *How to Draw Animals* (Grosset & Dunlap).
Laidman, Hugh, *Animals: How to Draw Them* (Dutton).

Mood and Philosophy Behind Comics

Lee, Stan, *Bring on the Bad Guys* (Simon and Schuster).
————, *Origins of Marvel Comics* (Simon and Schuster).
————, *Son of Origins of Marvel Comics* (Simon and Schuster).
————, *The Superhero Women* (Simon and Schuster).

ACKNOWLEDGMENTS

The illustrations used in this book were drawn by the following artists, who are among the greatest and most respected names in the comicbook field. We thank them, one and all.

(In alphabetical order)

Pencilers: Neal Adams Gene Colan
 Ross Andru Jack Kirby
 John Buscema John Romita

Inkers: Mike Esposito Paul Reinman
 Frank Giacoia Joe Sinnott
 Jim Mooney George Tuska
 Tony Mortellaro John Verpoorten
 Tom Palmer Al Weiss